JAZZ
UP YOUR
JUNK
with
LINDA
BARKER

JAZZ
UP YOUR
JUNK

with

LINDA
BARKER

Fabulous furniture
makeovers from the
star of BBC TV's
Changing Rooms

David & Charles

For Jess

AUTHOR'S ACKNOWLEDGEMENTS

For Ray, Rishi, Dominic and Nikki at Ray Munn, many thanks for supplying all the paint and products needed to put this book together. Thanks also to Lizzie for her wonderful photography which never fails to take my breath away, and to Jo for her considered and thoughtful styling. For Jane Forster and Shona Woods, many thanks for their unfailing commitment on this project. Thanks to Sally Barker for her hard work in getting the projects out of the workshop in time. And finally . . . thank you to the team at David & Charles who helped pull it all together.

A DAVID & CHARLES BOOK

First published in the UK in 1998

Copyright © Linda Barker

A catalogue record for this book is available from the British Library.

ISBN 0 7153 0832 7

Main photographs: Lizzie Orme
Step-by-step photographs: Shona Wood
Author photograph: Libi Pedder
Designer: Jane Forster
Stylist: Jo Rigg

Printed in Italy by LEGO SpA
for David & Charles, Brunel House,
Newton Abbot, Devon

Contents

Introduction

It's a passionate experience seeing and then realizing the potential of someone else's old junk. Well, it's certainly a passion shared by me and an ever growing number of you who have been bitten by the same bug. Judging from the sales of my first book on the subject, *Just Junk*, it seems as though we're all riding high on the idea of making something glorious from someone else's cast-offs.

There are few things more rewarding than hunting out hidden treasures in a salvage yard, junk shop or flea market, and finding either a gem of a chair, a dilapidated cupboard or a luxurious pile of old lace and linen. But whether the junk consists of shabby old chairs, cupboards with no doors, or doors with no cupboards, it's all worthy of rescuing. It just depends on how much time you've got to jazz it up. Take a gamble on a dilapidated piece, even though you can't think where on earth you might put it. Keep it for a while, read this book, then wait for inspiration to strike. Your makeover can be as simple or as complicated as you like – the main thing is not to be afraid to have a go. With junk it's not as if you've got a great deal to lose. It's far

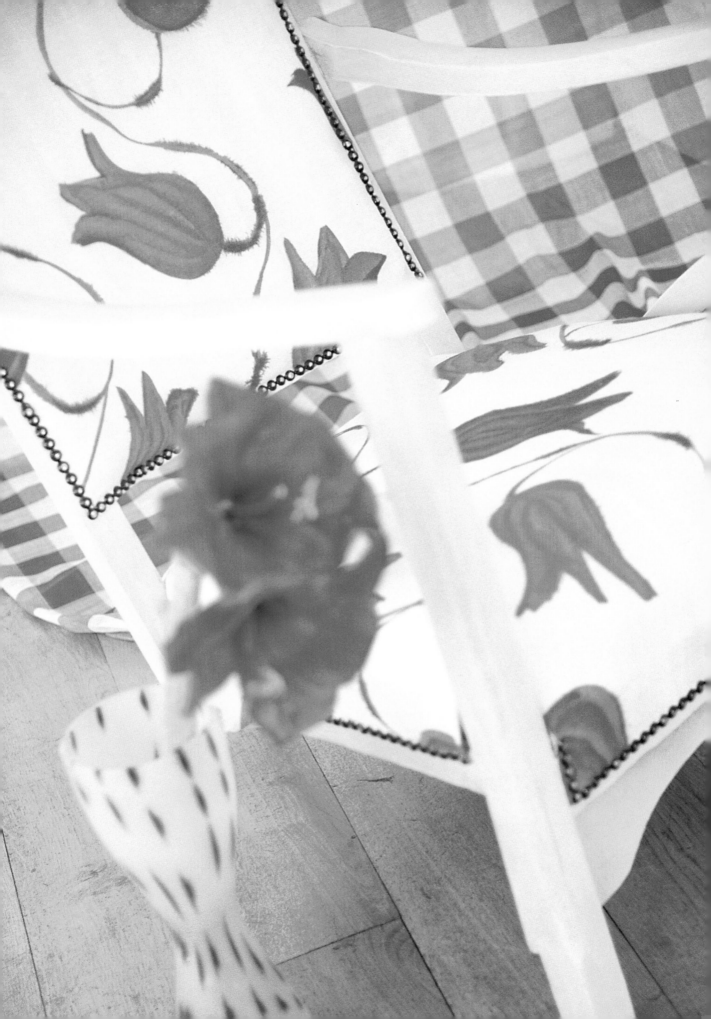

more likely that after you have completed one piece, you'll end up hooked and compelled to look for the next bargain.

There are certainly bargains to be had, particularly among the real junk pieces: all those ghastly pieces of brown furniture (it's nearly always brown) that collect dust in garages and sheds; the tatty black ash or white melamine furniture whose time simply came and went; and any number of old desks, tables, wardrobes and dusty cupboards. I bet we've all got a bit of junk lurking somewhere, tatty looking, neglected and unloved, but with great potential. Of course, real junk should not be confused with 'artistic' junk, such as the highly covetable cafe chairs with a hint of distressed paintwork or a shapely cabinet with the delicate 'bloom' of fading old age and elegance. No, real junk consists of those nasty pieces with blistered veneer and peeling formica: the grotty stuff, and I love it!

In this book I will show you exactly how to spot the potential in a piece of salvaged junk and how to revamp it into something altogether more desirable. The step-by-step photographs will guide you through the process, making the junk transformation a more bearable experience. When you've got your junk home, and it is looking sad and pathetic in its raw, untouched condition, I hope you'll enjoy transforming it just as much as the final transformation. Which is exactly what I have done while producing this book. Good luck!

GETTING HOLD OF JUNK

If you've never been to a furniture auction, then go to one. Details are usually printed in the local press and some of the bigger ones pull in people from miles around. The best one I visited was in Norfolk where, armed with bidding papers and pencil, I prepared to do battle. I did not exactly come away with any bargains . . . well, nothing at all, but it was a great experience! I've sharpened up my act now, and the whole event is still an enormous pleasure. The next best stop to an auction is a well-stocked junk shop. A good junk shop in my estimation is one that hangs just about everything outside on metal 'S' hooks. It's almost guaranteed to be crammed inside with clutter, rubbish (a lot of it) and salvage. Some junk shops are quirky and fun whereas others are distinctly downbeat. But both have their attributes and in the latter you're more likely to get the best bargains. Once you've discovered a good junk shop, pop in each time you're passing and you'll soon get a feeling for the type of stock, and the best days of the week to be in the area: traders often buy from a regular source and stock up the shop the next day.

Garage sales, yard sales and boot sales are held all over the place, and can all turn up great pieces of junk. City street markets are another favourite junk haunt of mine. Don't forget the humble charity shop and 'goods for sale' sections in the local press. Advertising papers are also worth scouring, but you've got to be quick to get the best buys. Finally, don't forget to look in loaded skips – although you will need permission to recover any booty!

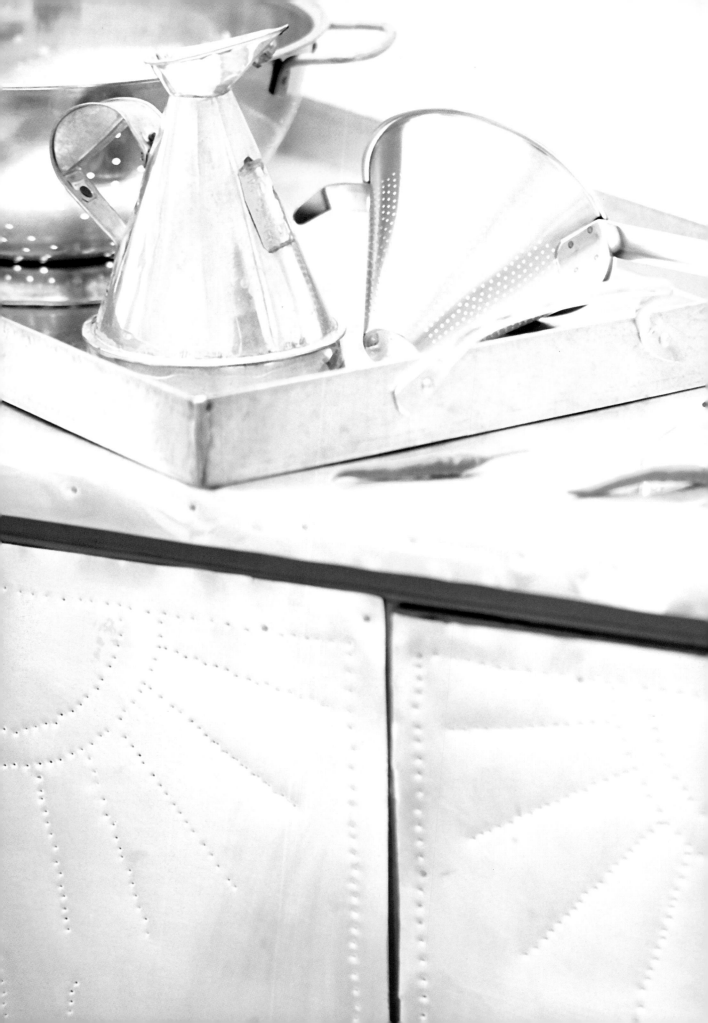

The
KITCHEN
& Dining
Room

Dining chair

A full set of chairs for the dining room is usually an expensive outlay, but revamping old seats into elegant dining chairs actually costs very little. With a modicum of skill and dexterity, a dining chair like this is easy and rewarding to build yourself. Battered old chairs can be found in most junk shops. To assemble a set, buy odd ones here and there and don't worry about mismatched legs or seats. Drop-in seat bases are the easiest to cover so if you find that you have a choice of chairs then opt for these first. Look out also for sturdy legs: there's simply no point buying a chair that wobbles. Strong uprights on the backrest support are also important, as the two uprights will form the main support for the shaped panel.

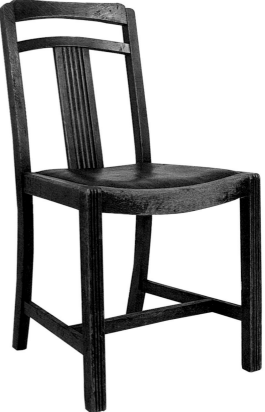

MATERIALS

old wooden dining chair
MDF, 25mm (1in) thick
template for chair back
long wood screws
wood filler
white acrylic primer
deep blue emulsion paint
acrylic varnish
wadding, if necessary
fabric for seat cover

EQUIPMENT

jigsaw
pencil
photocopier
carbon paper
protective face mask
electric drill and bit
narrow profile jigsaw blades
countersink bit
filling knife
power sander or fine sandpaper
household paintbrushes
scissors
staple gun or hammer and tacks

TREATMENT The shaped panel is made from 25mm (1in) thick MDF. You may need to buy this from a timber merchant rather than a DIY store as this thickness is not normally used for DIY projects. Thinner MDF may not provide the support that is necessary for a high-backed chair.

The detailed panel is cut with a jigsaw that has been fitted with a narrow profile jigsaw blade. This blade is thinner than the conventional wood-cutting blade and it enables the saw to cut around corners and curling shapes. It is a good idea to practise the cutting technique on a piece of scrap timber before you embark on the real thing, to give you a feeling for the cutting.

1 Place the base of the jigsaw flat against one of the uprights of the chair back. Cut away the joints that secure the backrest to the upright, then repeat with the other upright and the chair base. Remove the backrest, leaving the two uprights intact.

2 Place a sheet of MDF on the seat of the chair, resting it against the uprights. Using a pencil, mark the positions of the two uprights on the MDF. These may slope outwards towards the top.

3 Photocopy and enlarge the template at the back of the book so that the template fits the width of the chair back. Adjust the template as necessary to fit your chair. Transfer the design on to the MDF using carbon paper.

4 To cut out the intricate curves of the backrest design, you will need to drill holes into the MDF to provide access for the jigsaw blade. Wearing a protective face mask, drill five or six holes in areas that will be cut away.

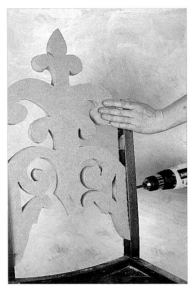

5 Place the MDF between pieces of timber or use a work bench. Using a jigsaw fitted with a narrow profile jigsaw blade, carefully cut out the shaped backrest. Work slowly and never force the blade along.

6 Place the shaped backrest in position between the chair uprights. Mark three screw positions down each upright for screw fixings that will join timber and MDF. Pre-drill the holes using a drill bit slightly narrower than the screw, countersink then screw together using long wood screws.

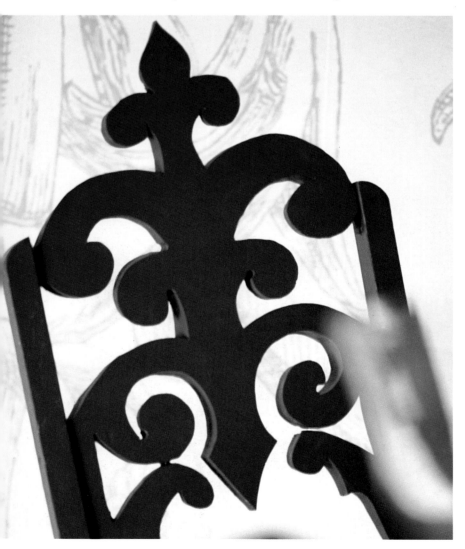

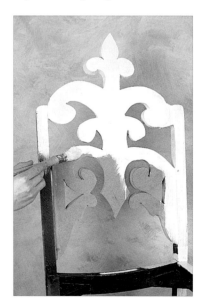

7 Fill the countersunk holes with wood filler, allow to dry, then sand the filler until it is level with the surface of the wood. Prepare the chair frame for painting then apply a coat of white acrylic primer all over. Allow to dry.

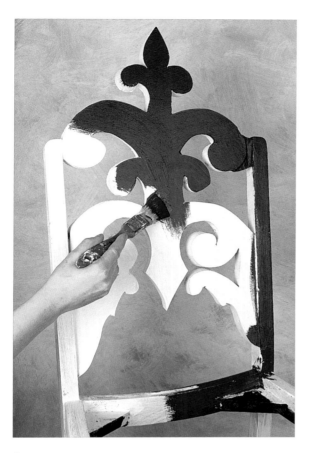

8 Paint over the primed chair frame with deep blue emulsion paint (or a colour of your choice). Pay particular attention to the chair back, as all the cut edges need to be painted carefully. Allow to dry, then varnish the chair for protection.

9 Remove the old seat fabric and discard. Place a layer of soft wadding over the base, if desired, then re-cover the seat using fabric of your choice. To do this, cut out a piece of fabric 5cm (2in) larger all round than the seat base. Place the seat base, with wadding in place, upside down on the fabric. Fold the fabric over the seat edges and secure with staples using a staple gun, or with tacks and a hammer. Mitre the corners for a crisp finish. Slot the seat into the chair frame to finish.

Tea
trolley

It was with a sigh of relief, and even a sense of bewilderment, that my local junk shop let this rather grubby-looking tea trolley go. But I thought it was a lucky find; the trolley was in good condition with brass rails at each side and castors which were in perfect working order. All it needed was some imaginative paintwork to transform its looks. The trolley, once painted, is attractive enough to be used as a side-table either in the kitchen or dining room, and can be easily moved to where it is needed. As kitchens become more streamlined and compact, you could use a trolley simply as an ingenious movable shelving unit on which to store glasses, pasta jars or cooking spices.

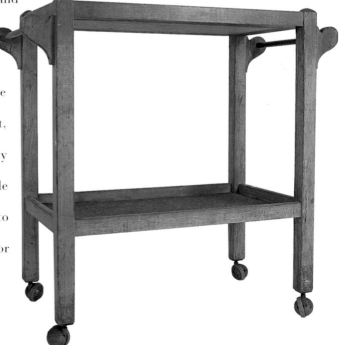

MATERIALS

tea trolley
white acrylic primer
turquoise emulsion paint
tracing paper
green acrylic colour
white acrylic colour
magenta acrylic colour
acrylic varnish

EQUIPMENT

medium-grade sandpaper
household paintbrushes
pencil
fine artist's brushes
old plate

TREATMENT With a traditional English tea ceremony foremost in my mind, I chose to give this trolley an unashamedly romantic, early 1950s tea room treatment: pink flowers over a soft turquoise background with leafy sprigs at the sides. The dull brown wood responded beautifully to paint and looked much fresher as a result. The flowers are easy to paint once the outline has been drawn in. The templates for these flowers appear at the back of the book.

1 Remove any old coverings that may be stuck to the tray surfaces. This sticky vinyl was easy to remove; it simply peeled off to reveal the protected surface of each tray.

2 Using medium-grade sandpaper, rub the entire trolley to remove any old varnish and dirt. Depending on the condition of your junk find this could involve a quick sand with a power sander or an hour or two by hand.

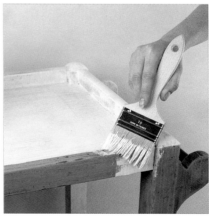

3 Apply a coat of white acrylic primer over the underside as well as the top surfaces of the trolley. Allow to dry. This will smooth out any small imperfections as well as providing a good base for the top colour.

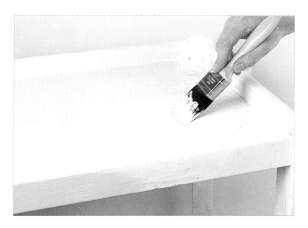

4 Apply two coats of turquoise emulsion paint, allowing the first to dry before applying the second. Turn the trolley upside down when the top surfaces are dry to access and paint the underside.

5 Trace the flower templates at the back of the book, then place the tracing pencil-side down on the painted surface and re-trace along the outlines to transfer the design. Repeat with as many flowers as necessary.

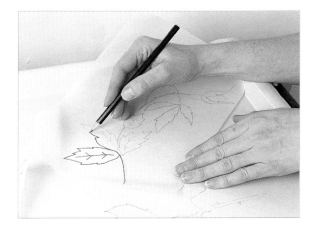

6 Transfer the occasional simple leaf shape to add interest to the design. Twist and turn the traced outlines to avoid building up a regular pattern on the trolley.

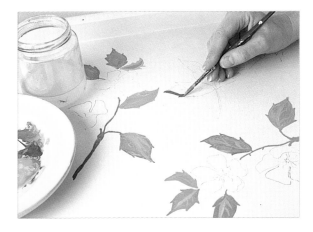

7 Using green acrylic colour and an artist's brush, outline the foliage, then dilute the paint with a little water and fill in the leaves. Add a little white acrylic colour to the green to paint 'veining' details.

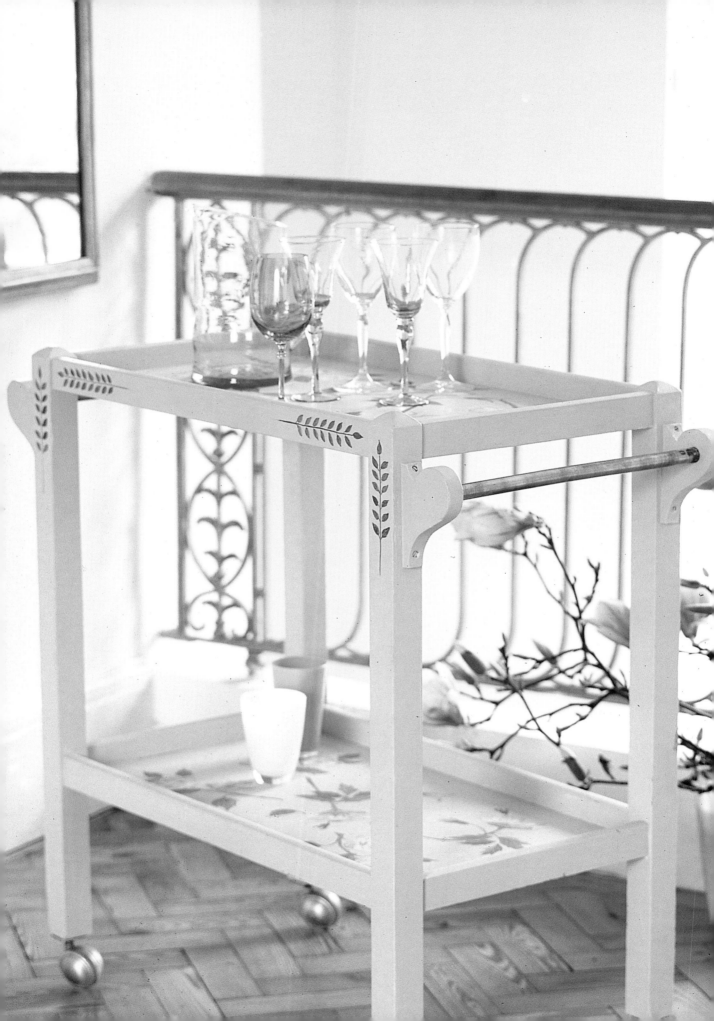

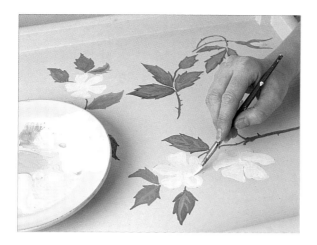

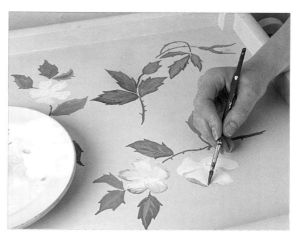

8 Squeeze a little magenta and white acrylic colours on to an old plate to produce a variety of pinks for the rose motif. Mix these at random, adding water where necessary, to produce several different pink tones. Paint the roses with the paler pinks first.

9 Add stronger pink colouring around the tips of the rose petals to give a sense of depth and achieve a more realistic-looking flower. Using thinned washes of this deeper colour occasionally will give a pretty effect. Take care not to smudge the fresh paint.

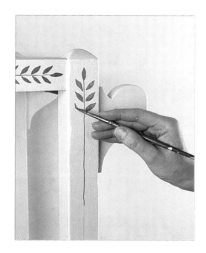

10 Pencil leafy sprigs at the corners of the trolley. Paint the outlines of the leaves and the stem in green, then fill in with the same colour. Allow to dry, then protect and seal the painted finish with two coats of acrylic varnish.

Punched tin cabinet

This piece of furniture is traditionally known as a tallboy and is normally used in a bedroom. However, I thought the proportions were perfectly suited for use in a kitchen, as a larder cupboard. Many kitchens now successfully incorporate freestanding units in their design to create a more relaxed and less clinical feel and this unit seemed perfect for the role. Very little work needed to be done to transfer its use from bedroom to kitchen. The top part of the unit could easily be converted into storage space for tins, bottles and jars, while the drawers at the base are a good size for cookery books, particularly when these are placed spine uppermost, or could be used to store table linen and tea towels.

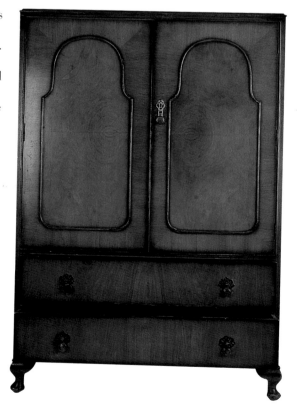

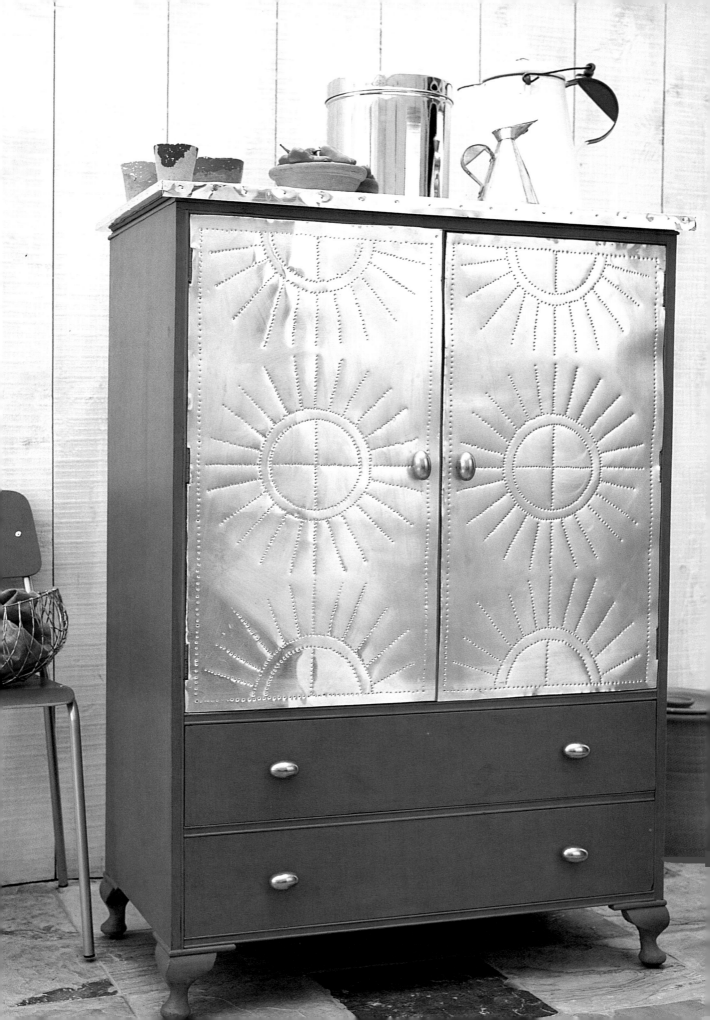

MATERIALS

E.S.P.
blue emulsion paint
brown paper
3 aluminium sheets
spray mount
panel adhesive
panel pins
MDF (or timber) replacement
 top
dark oak buffing wax
replacement door knobs

EQUIPMENT

power sander or sandpaper
cloth
household paintbrush
scissors
pencil
saucer
old scissors or tin snips
cutting mat
hammer
nails

TREATMENT Although the moulding on the cupboard doors was an attractive shape I felt that this needed to be removed as it did not suit the rustic, Mexican-style treatment I had planned. The handles also had to go, and I replaced these with oval-shaped, pewter-effect 'nuggets' which complemented the shiny aluminium sheet perfectly.

Steel, zinc and aluminium sheets are available from good DIY stores and are quite easy to cut. I used aluminium sheet which is a little more expensive but quite a soft metal, making it easier to 'punch'. Steel and zinc sheet should be cut with tin snips, but this sheet is soft enough to be cut with an old pair of scissors.

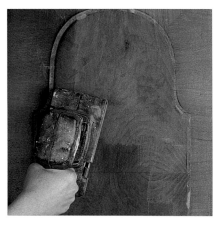

1 Remove the mouldings and sand this part of the cabinet until smooth. Prepare the unit thoroughly using E.S.P. (see page 127).

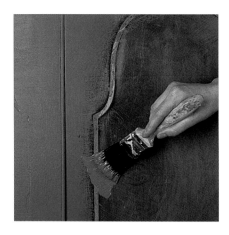

2 Paint the entire unit with vibrant blue emulsion paint. When dry, apply a second coat for good coverage.

3 Cut a piece of brown paper to the size of a cabinet door. Fold it into quarters then open it out again. Draw on the outlines of the design using the template at the back of the book as a guide. Use a saucer or plate to help you plot the lines.

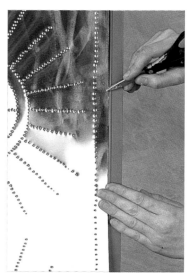

4 Cut two aluminium sheets to the size of the doors. Sand the edges to smooth them. Stick the brown paper to one of the metal sheets with a small amount of spray mount. Place the metal sheet on to a cutting mat and punch through the lines of the design with a hammer and nail, making small holes every few millimetres. Repeat for the second door.

5 Lay each punched metal sheet against the cupboard door and mark off the position of the hinges. Cut out this small section from the metal sheet.

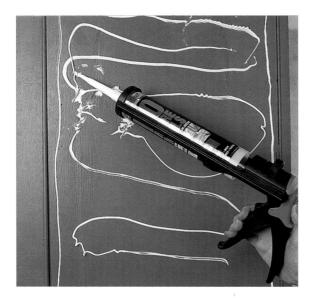

6 Apply panel adhesive liberally across the front of both doors. This adhesive will bond the metal sheet to the wood; if the doors are large like these, you will need to use panel pins for extra security.

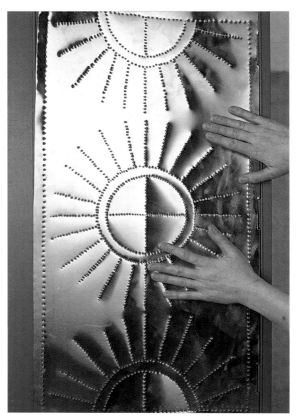

7 Press the punched metal sheet over the wet adhesive and place heavy weights on top to ensure that the metal remains in contact with the door underneath. Allow to dry for several hours, when the adhesive should be firm to the touch. Then hammer panel pins around each panel for added security.

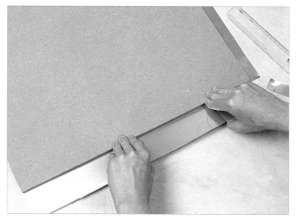

8 Cut a new top for the cabinet from MDF. Cover the MDF top with a third piece of aluminium sheet. To do this, place the MDF on the metal sheet, allowing for an overlap on the two shorter sides and across the front. Score the metal with old scissors along the overlaps, cut away the corner pieces, then fold the metal over the MDF. Secure with panel pins.

9 Using a soft cloth, apply a patchy coat of tinted buffing wax over the painted surface of the cabinet. I used a dark oak wax as this has the deepest colour. Furniture wax can be used instead of buffing wax if preferred. This will create an impression of age.

10 Fix replacement knobs to the cabinet using the existing holes where possible. If the old holes have been covered by metal sheet, as on the top part of this cabinet, punch a nail through the old hole at the back of the metal sheet with a hammer, then fix on the new knob.

Candlesticks

Some of these pieces of timber were quite literally rescued from a bonfire. Sadly, several rather more elaborate pieces were already charred and smouldering as I gazed into the glowing embers but this quickly prompted an investigation into the remainder of the woodpile. The booty, although initially uninspiring to look at, was transformed into rather wonderful, tall and elegant candlesticks.

Items similar to these – odd, turned table or stair parts – usually cost very little as they have no practical value for furniture projects, and they can sometimes be found in cardboard boxes tucked away under dusty tables in junk shops. A variety of shapes can be turned into a coherent group. Stand several candlesticks together and top with large beeswax candles to create simple yet dramatic lighting in a dining room. Tall candlesticks like these are very elegant simply placed on the floor.

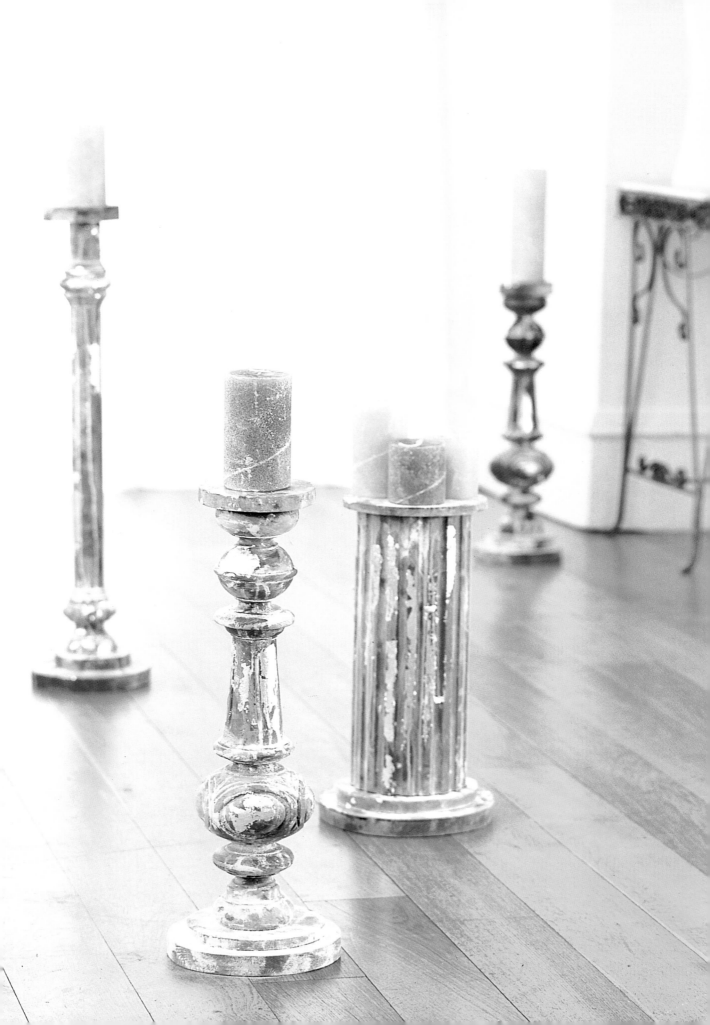

MATERIALS

pieces of timber
scraps of thick MDF
wood glue
long wood screws
E.S.P.
mid grey emulsion paint
black acrylic colour
water
dark grey emulsion paint
scrap of muslin
powdered filler
Dutch metal leaf
acrylic gold size
spray matt varnish

EQUIPMENT

felt-tip pen
plates and saucers
jigsaw
protective face mask
medium-grade sandpaper
electric drill and bit
screwdriver
cloth
household paintbrush
artist's brush

TREATMENT Adding layers of thin diluted emulsion in shades of grey will build up an interesting paint finish reminiscent of old pewter. Start by painting on the darkest grey, which should be a solid base colour. Then add a thin coat of black acrylic colour and dribbles of grey. Soften any dribbles that turn into 'rivers' of paint: this happens even in the most experienced hands. Before you start, however, remember to protect your work surface before that too is given a pewter effect.

1 To make the base and top for each candlestick, draw at least two circles on a piece of MDF with a felt-tip pen; use plates and saucers as templates to draw around. In some cases I have used three discs of varying sizes to build up an attractive shape.

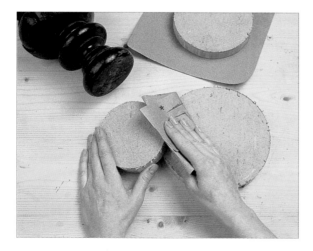

2 Cut out the discs using a jigsaw, then smooth the rough edges with medium-grade sandpaper. Always use a protective face mask when working with MDF and work in a well-ventilated area to prevent inhalation of the fibres.

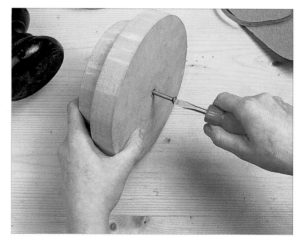

3 To join two discs together for the base, drill a hole at the centre of each disc then countersink the hole at the base of the largest disc. Fix the discs together with wood glue, then screw a long wood screw through both discs and into the base of the candlestick.

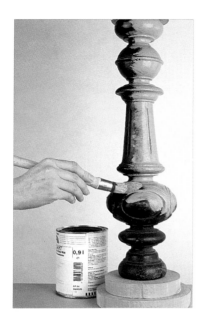

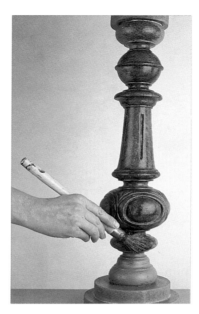

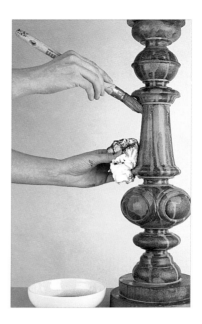

4 Use E.S.P. (see page 127) to prepare the wood before painting. Then brush one coat of mid grey emulsion paint over the entire candlestick. Allow time to dry; if this should look at all patchy, brush on a second coat to achieve an even coverage.

5 Squeeze a small amount of black acrylic colour on to a saucer or palette. Dilute this with about the same amount of water and apply in splodges over the dried base colour. Aim for a patchy effect which allows the base colour to be seen through it. Leave to dry.

6 Dilute some light grey emulsion paint with water. Starting at the top of the candlestick, apply the watery paint and allow dribbles of the colour to trickle down. Keep a cloth in your other hand to soften heavy floods of colour.

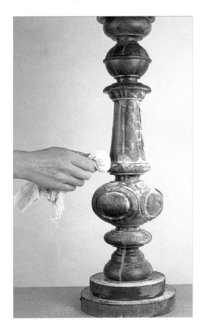

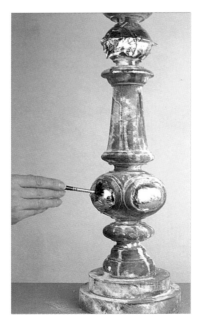

7 Make up a little 'pounce bag' using a scrap of muslin or other looseweave fabric, and fill it with powdered filler. Gather it into a bag and 'pounce' or dab over the wet surface of the candlestick to build up a dusty patina.

8 Allow the candlestick to dry, then add sparkling highlights with Dutch metal leaf. Brush off the loose leaf with an artist's brush, then spray a layer of matt varnish over the candlestick for protection.

Armoire

Large wardrobes like this one can often be bought fairly inexpensively at many junk shops due to the fact that they are difficult to move around. they are usually very heavy. and they take up lots of valuable space. I'm sure the man who sold this huge. solid wardrobe to me was more than delighted to get it out of his small shop. It was so heavy. it took three men to lift it into my studio!

The decorative profile on the top of the doors reminded me of the curved shape of traditional French armoire doors and it was this small detail that convinced me that this cumbersome piece of bedroom furniture was going to make a great storage unit for a kitchen. Huge kitchen cupboards are stylish as well as practical. Once the hanging space was filled with several drop-in shelves the storage space was vast. almost enough for an entire kitchen.

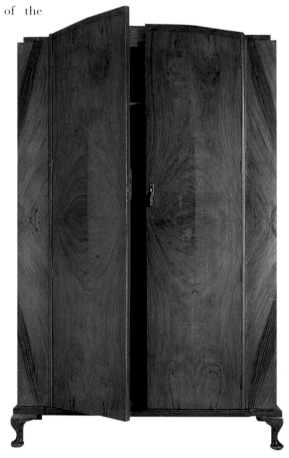

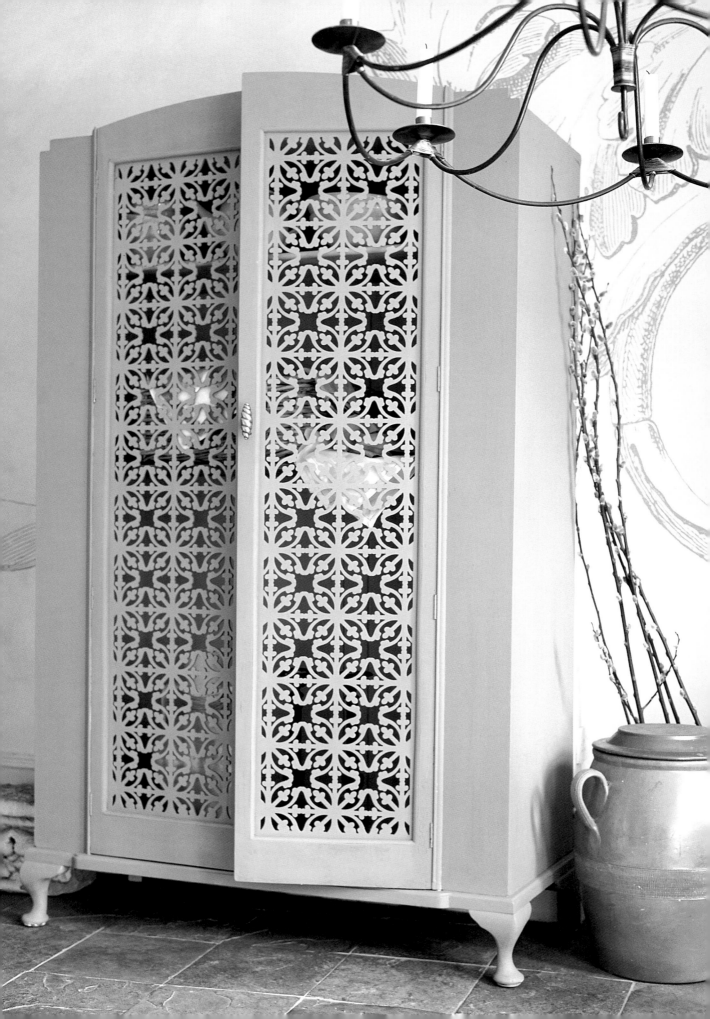

MATERIALS

wardrobe
fretwork panels
glazing bars
panel pins
narrow pine moulding
wood filler
green emulsion paint
ivory emulsion paint
timber/MDF for new shelving
screws
acrylic varnish
replacement handle

EQUIPMENT

power drill
power jigsaw
small hammer
nail punch
paintbrush
screwdriver

TREATMENT The solid construction of the doors was one of the reasons the cupboard was so heavy and cumbersome. Once the main part of the doors was cut away and replaced with decorative fretwork panels, the wardrobe took on a less funereal appearance. The open fretwork also made more practical sense for a kitchen cupboard that would need circulating air. The interior of the cupboard was kept bright and fresh with a soft ivory paint colour, as a marked contrast to the more sombre green used on the exterior. The colours were painted in solid blocks and required only a coat of matt varnish for protection.

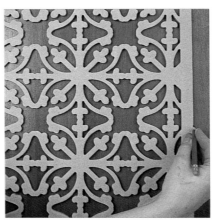

1 Remove the doors from the wardrobe and mark the position of the fretwork panels against the front of each door, as a guide for the jigsaw. The fretwork screens can be made up to your exact requirements, so keep the retaining borders as small as possible.

2 Drill a hole into each corner of the proposed panel area, to allow the blade of the jigsaw to pass through. Using the jigsaw, saw along the drawn line, never using force to push the blade along. Remove any lock or handle mechanisms that may get in the way of the blade.

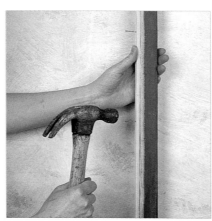

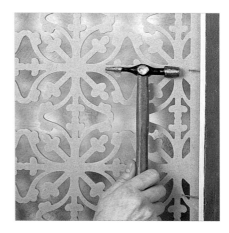

3 Tap a narrow glazing bar along the inside edge of the open door panel. This will hold the fretwork panel and prevent it from falling straight through. Use panel pins spaced regularly along the length of the glazing bar to hold it securely in position.

4 Position the fretwork panel against the secured glazing bars, keeping the doors flat whilst you are working. Use strips of a narrow quadrant moulding to hold the fretwork panel in position. Use panel pins to secure. Use a nail punch to sink the heads of the panel pins below the surface then fill with an all purpose filler.

5 Paint the exterior of the
wardrobe with green emulsion
paint. Paint the interior with ivory
emulsion. Leave to dry. Decide on
the number of shelves you require.
Screw wooden battens to each
side of the wardrobe to hold the
new shelves in place. Varnish the
cupboard inside and out and leave
to dry. Screw a replacement door
handle to the door if required.

The
LIVING
ROOM

Organza screen

Old doors can make fantastic screens for the living room. My local salvage yard had a pair of these fabulous panelled doors that were perfect for such a transformation. Although the panels on these doors were empty, do not feel you must limit your search for similar empty panelled doors to achieve this type of screen. Solid panelled doors will work equally well as a screen: all you need to do to these is to jigsaw the panels out! (See the Linen cupboard project on page 68 for advice on how to cut out panels.) Likewise, if your salvaged doors have four panels, you can simply cut these in half. When looking through junk and salvage, learn to appraise it in a constructive way: you may not find exact replicas of the junk featured here, but you can use similar pieces to create a similar effect.

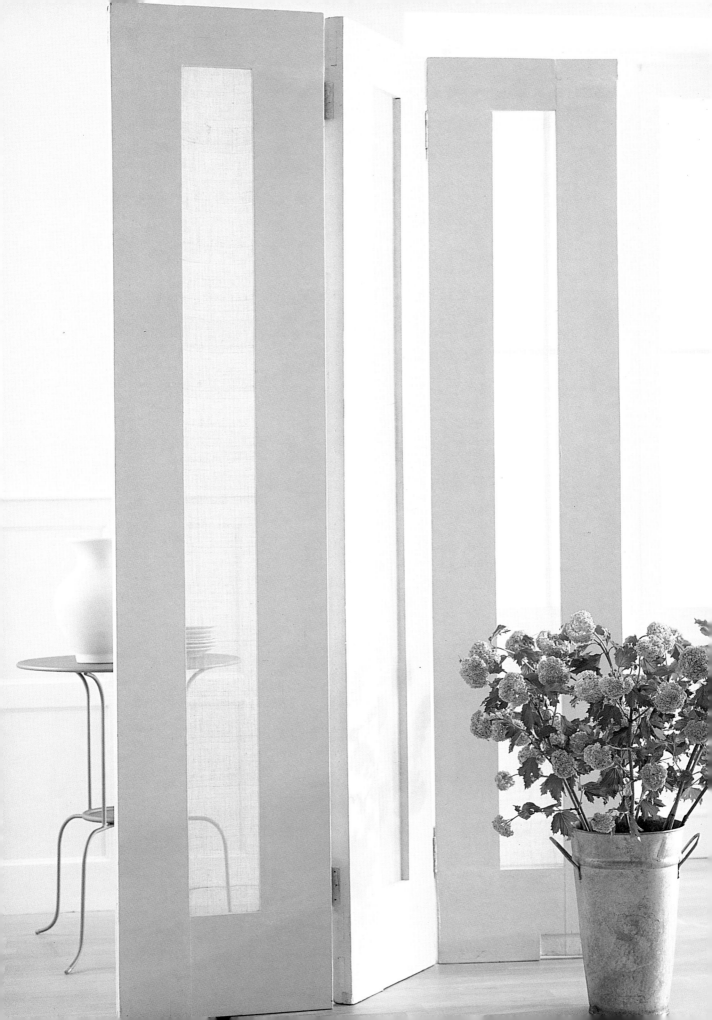

MATERIALS

panelled doors
white acrylic primer
lilac emulsion paint
acrylic varnish
semi-transparent lilac organza
quadrant moulding
panel pins
strong hinges
screws

EQUIPMENT

jigsaw
power sander
household paintbrushes
tape measure
scissors
staple gun and staples
hammer
screwdriver

TREATMENT Screens are excellent both for blocking off an area behind them and for creating a dynamic, architectural shape in a room. They can block out light, however, which is why I chose semi-transparent organza to fill the open spaces in these tall elegant panels. If you need a screen to hide something that is behind it – for example, a mass of shelving in a bedroom – then use several layers of fabric rather than a single thickness to create a denser shield that will prevent anyone seeing through. For those used to small-space living, a screen can be folded back to uncover a work space in a living room then simply opened out when the room is needed as a relaxing, non-work space.

1 Use a jigsaw to cut the door into long thin panels, either three as here, or two for a four-panelled door. Make sure the salvage yard is aware you are doing this; a scruffy pine door is better for this purpose rather than anything made from good timber.

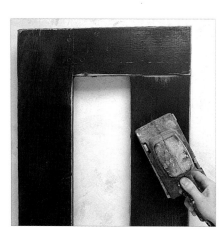

2 Remove any protruding nails, then smooth down the surface of the panels with a power sander. Use a medium-grade sandpaper first, then finish with a fine-grade one. Work against the grain, then finally with the grain for a perfectly smooth finish.

3 Apply a coat of white acrylic primer to both sides of each panel. Paint across the glazing bars and at the top and bottom of the panel too as these will all require painting later on. Leave to dry.

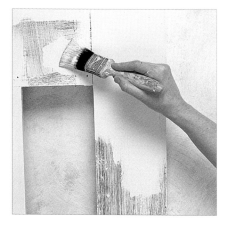

4 Apply two coats of lilac emulsion paint over each panel, allowing the first coat to dry before applying the second. Allow to dry, then apply a coat of acrylic varnish for protection.

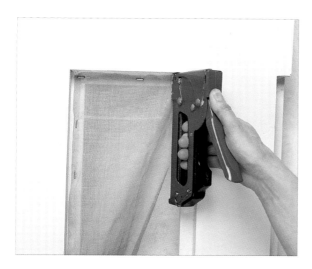

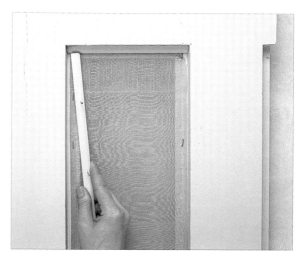

5 Measure the gap in each panel and cut pieces of organza accordingly. Do not be tempted to cut the fabric with any extra allowance as this will only bunch up when in the screen and make it difficult to fit the moulding over the ends. Staple the fabric in place in the gaps, pulling it taut as you go.

6 Cut pieces of moulding to fit the gaps, allowing for joints at the corners. Paint each piece of moulding with a quick coat of primer then with lilac emulsion. Allow to dry, then use a hammer to knock panel pins through the moulding to secure it in position over the staples.

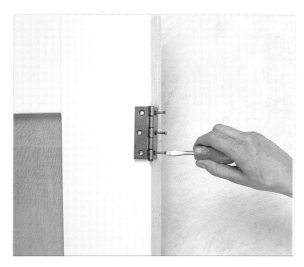

7 Measure and mark the positions where the hinges should be attached on the screen; two hinges should be sufficient for each side. Using a screwdriver and screws, fix the hinges in place. To make the screen fold in the characteristic zigzag shape, screw one pair of hinges to the front of the screen, opening inwards and screw the second pair to the back of the screen, opening outwards.

Writing desk

'Very cheap and a really rather nasty piece of junk,' was how someone described this desk to me, which I thought rather unfair in the circumstances. A piece of junk it certainly was but it was definitely worth rescuing. And of course it was cheap, but you would never know from seeing it after its final transformation.

When you are buying junk you have to teach yourself to look behind the brown veneer of dirty old varnish that covers so many of the pieces. Behind the brown veneer of this desk, the proportions were lovely, and the simple compartments inside were easily made more attractive by the addition of elegant arched front pieces. Classic new handles are the perfect finishing touch.

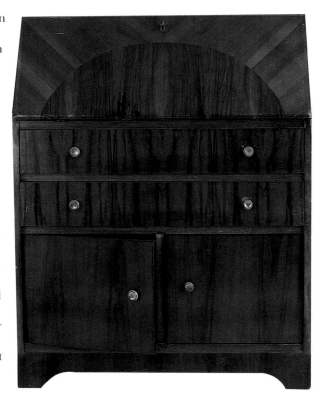

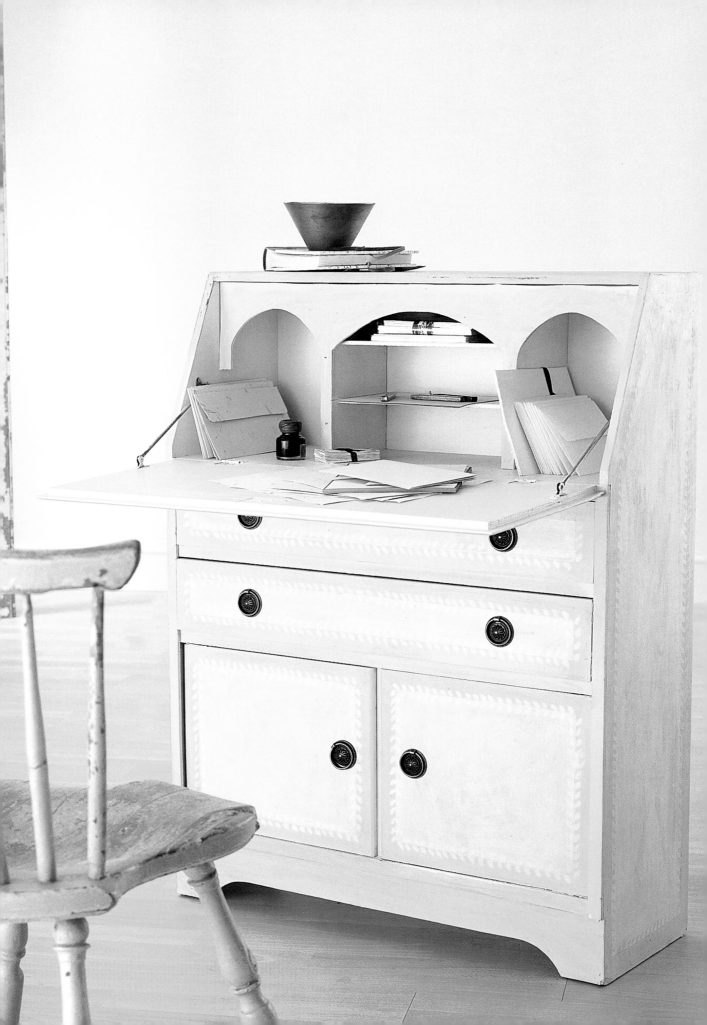

MATERIALS

desk
E.S.P
yellow emulsion paint
ivory emulsion paint
tracing paper
carbon paper
terracotta acrylic colour
duck-egg blue acrylic colour
MDF, 6mm (¼in) thick
panel pins
white acrylic primer
acrylic varnish
dark oak furniture wax
replacement handles and screws

EQUIPMENT

cloth
household paintbrushes
ruler
pencil
fine artist's brushes
masking tape
jigsaw fitted with narrow profile
 cutting blade
medium-grade sandpaper
hammer
hacksaw, if necessary
fine-grade wire wool
screwdriver

TREATMENT The style of decoration for this desk follows a neo-classical theme, although here I used bolder colours. But it is the combination of colours on this desk that work so well. The duck-egg blue against the primrose yellow seems to vibrate a little while the terracotta punctuates the two colours perfectly. I use coloured furniture wax again in this project, as I have done for several pieces of furniture in the book. It is a technique that adds a certain 'bloom' to the matt quality of the paint. The wax adds a richness to the end result, intensifying the colours as well as protecting the final finish.

1 Prepare the surface of the desk using E.S.P. (see page 127). Apply a coat of yellow emulsion paint over the entire desk. Allow to dry, then apply a second coat. Leave to dry.

2 Using a long ruler and pencil, mark out an even border around each drawer front, around the cupboard doors, the sides of the desk and around the drop leaf. Next, mark on a diamond pattern at the centre of the drop leaf, by marking a point at the middle of each long side and the middle of each short side, then joining these points together.

3 Paint the outside of the diamond on the drop leaf with thinned ivory emulsion paint (diluted in the proportion of 2 parts paint to 1 part water) using an artist's brush to create a streaky look; paint as close as possible to the pencil lines. Repeat the same washed effect on the sides of the desk and on the cupboard door and drawer fronts, working inside the pencil lines.

4 Trace the design from the back of the book on to a piece of paper. Place the tracing on a piece of carbon paper and stick the two pieces over the border on the drop leaf with masking tape. Draw over the outline of the pattern to transfer it on to the desk. Move the pattern along and repeat the process to transfer the pattern all around the drop leaf. Space this outline regularly according to the width of your desk top.

5 Paint the curling part of the border outline on the drop leaf with terracotta acrylic colour; dilute this with a little water, if necessary, to make the paint flow more easily. Then, using the same colour, paint along the pencil line which separates the diamond area from the border area.

6 Thin a little of the duck-egg blue acrylic colour with water to make a flowing paint. Use an artist's brush to paint in the remaining parts of the border pattern and the leaf detailing around the washed ivory areas. Support your painting wrist with your other hand, if necessary, to keep your painting steady.

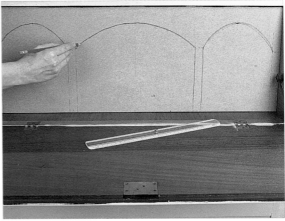

7 To make the arched compartments, cut a rectangle of MDF to fit across the compartments on the inside of the desk, having first marked in pencil the vertical positions of the shelf supports. Widen the vertical positions by 1cm (½in) on each side to make column supports of 2cm (¾in). Stop the columns approximately 7.5cm (3in) from the top of the desk, then connect each with a sweeping arch.

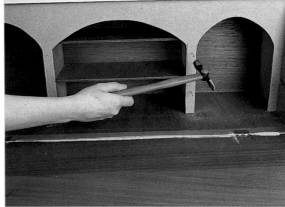

8 Using the jigsaw fitted with a narrow blade, cut out the shaped piece of MDF following the pencilled marks. Smooth the rough edges with medium-grade sandpaper. Insert the MDF in the desk, hammering panel pins in each vertical column to hold the arched section in place. Check that the closing mechanism of the desk can still operate; if necessary, trim off the lower section of the outside vertical columns with a hacksaw.

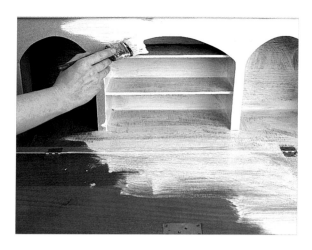

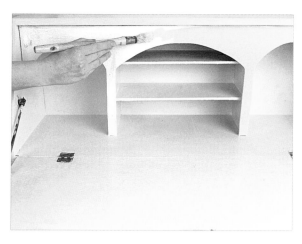

9 Prime the inside of the desk carefully using white acrylic primer. Use a small brush to access the tight corners and narrow shelf areas. Leave to dry.

10 Paint over the dried primer with yellow emulsion on the arched section and ivory emulsion on the rest. Apply a second coat of each colour when the first coats are dry. Any paint brushed over the hinges can be removed with fine wire wool when dry. Allow to dry, then varnish the inside of the desk for protection.

11 Apply dark oak furniture wax over the exterior of the desk using a soft cloth. Don't worry if the wax appears darker in some areas than in others. The thinned ivory paint will darken rather more than the other colours and this effect adds to the overall appearance of the desk. Attach the replacement handles with screws to complete the desk.

Découpaged cabinet

A friend gave me this elegant cocktail cabinet as she was tired of the dark brown, rather austere appearance, and I had to agree. But although the decoration was sombre, the piece of furniture was in wonderful condition. The doors of the cabinet open to reveal a mirrored back with compartments for glasses, bottles and even an ice bucket. There is a special frame in the door which is designed to hold a small drinks tray, and there is even a light that comes on when the doors are opened. The exterior of the piece also displayed interesting features with its curved legs and intricate detailing. As the doors were very plain, with no mouldings, and of a generous size, they provided ideal areas for decoration. I felt the cabinet needed a soft and pretty finish so pale colours and flowers were chosen as the decorative scheme.

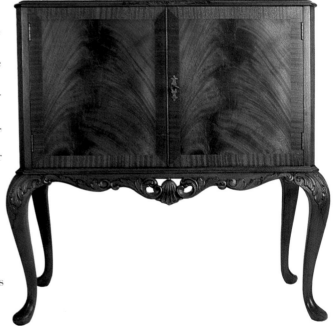

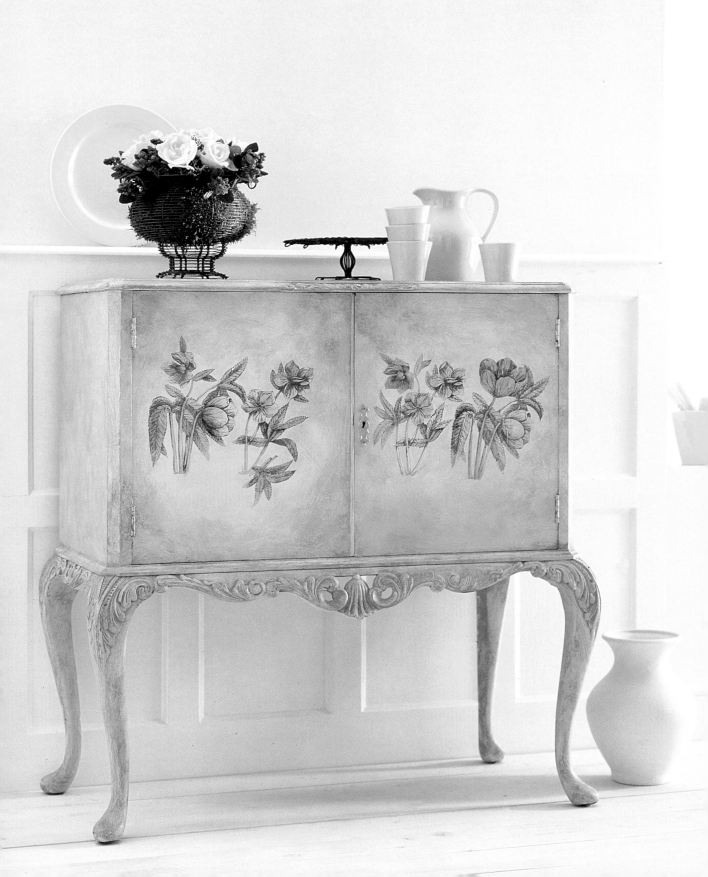

MATERIALS

cabinet
white acrylic primer
découpage motifs
watercolour paints
ivory emulsion paint
PVA adhesive
turquoise emulsion paint
acrylic varnish

EQUIPMENT

power sander
fine-grade sandpaper
household paintbrushes
photocopier
artist's brush
small scissors
glue brush

TREATMENT I chose a pale ivory for the base colour of the cabinet, then applied delicately tinted découpage on the doors before colourwashing the whole unit with a soft turquoise emulsion. The interior was painted using the same turquoise, only here with a flat, even finish. Two coats of varnish were applied to protect the finish from knocks and occasional spillages.

The flowers that were used for the découpage are reproduced at the back of the book, but you could substitute any other black and white image that you felt was appropriate. There are a number of copyright-free source books available either through libraries or bookshops, with a fascinating choice of images. Many are published by Dover Books; your library should be able to assist your search.

1 Prepare the surface of the cabinet prior to painting using a power sander and fine-grade sandpaper to lightly 'key' the shiny surface of the veneered wood. Paint the cabinet with a coat of white acrylic primer, then allow to dry.

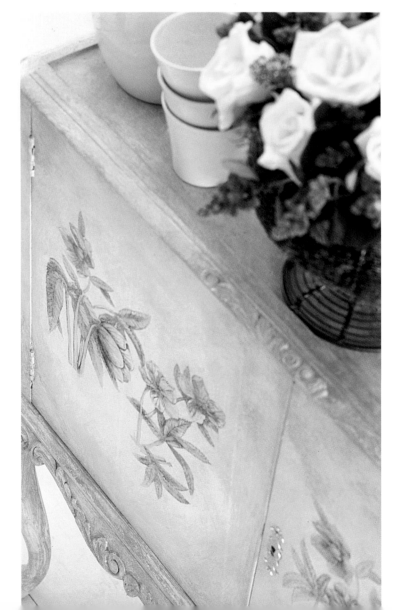

2 Photocopy the flower images at the back of the book using the enlargement facility on the copier; for a large cabinet like this one you will need to produce A3-size images. Using an artist's brush, tint the flowers with dilute watercolour paints; don't worry if the colour bleeds over the outlines.

3 When the paint is dry, carefully cut out the flower images with a small pair of scissors. Cut as close as you can to the printed outline as this will look neater and crisper on the finished cabinet.

4 Paint the cabinet with two coats of ivory emulsion paint, allowing the first coat to dry before applying the second, then allow to dry. Apply thinned PVA adhesive to the back of the cut-out flowers then position them carefully on the cabinet. The thin, slippery glue dries slowly, allowing time for repositioning if necessary. Brush the cut-outs gently with a glue brush to ensure they are lying flat and to remove any underlying air bubbles.

5 Mix a dilute solution of turquoise emulsion paint with an equal quantity of water and scrub the thin paint over the cabinet. Aim to create a halo effect around the flowers with heavier paint around the sides and legs of the unit. Allow to dry, then apply two coats of acrylic varnish over the entire cabinet for protection.

Striped pouffe

This 'before' photograph shows just how dated and inelegant the pouffe has become. It's no wonder that in every junk shop I visited. there was at least one sad. lonely pouffe just waiting for a makeover. This particular find was given to me by the junk-shop owner because he was fed up with it hanging around: what a tragic fate for a one-time great design item. The original 1950s-style fabric was sadly rather decayed on this pouffe. otherwise I would have tried to rescue it. Fabric designs from the 1950s are currently enjoying a revival in today's interiors so it would have been fun to use the fabric for a seat cover or upholstery project. As it was. the cover disintegrated almost to the touch. so I replaced it with calico before sewing on the new cover.

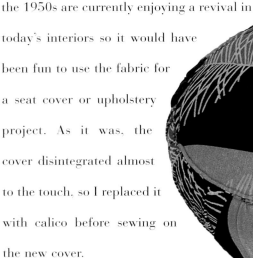
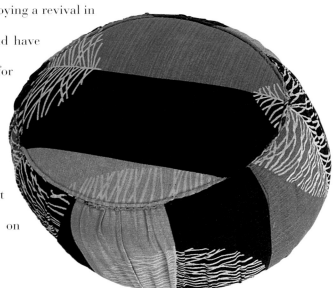

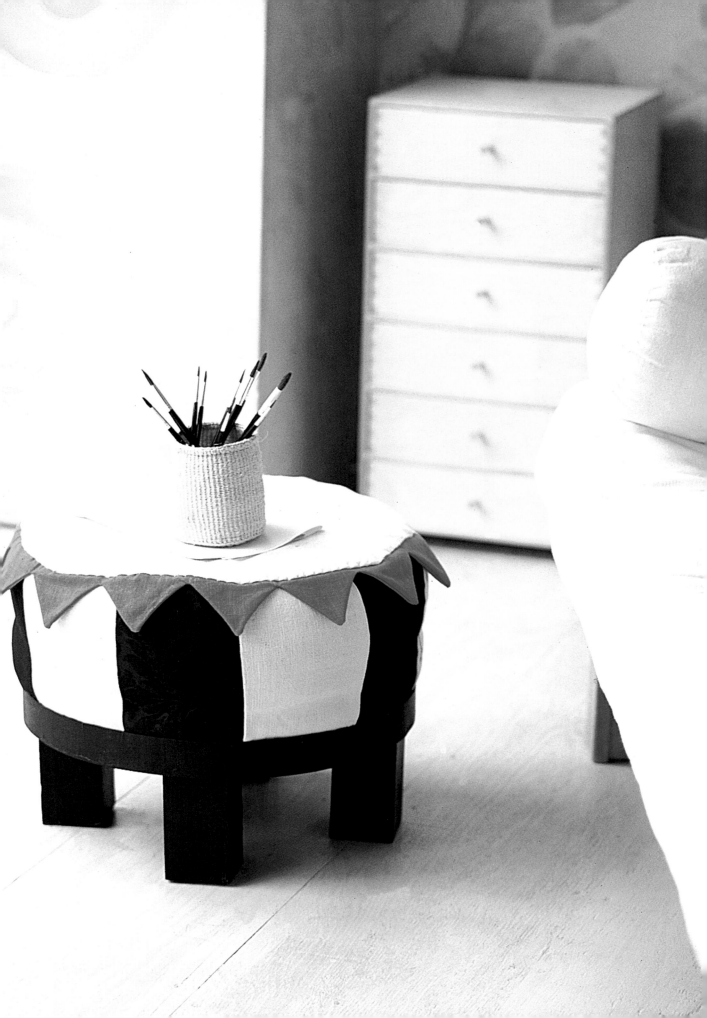

MATERIALS

pouffe
black fabric
white fabric
sewing thread
pink fabric
MDF, 9mm (⅜in) thick
flexiply
flat-headed tacks
40cm (16in) of 7.5x7.5cm
 (3x3in) timber for legs
wood glue
long wood screws
grey emulsion paint
black emulsion paint
acrylic varnish

EQUIPMENT

tape measure
dressmaking scissors
sewing machine
pencil
iron
pins
needle
string
scissors
hammer
nail
jigsaw
craft knife
steel ruler
saw
screwdriver
household paintbrushes

TREATMENT I needed a brand new look for the pouffe, so my first idea was to elevate the whole thing on to its own little stool. This gave the pouffe a dual purpose, primarily as a footstool but also as a seating option or a place to rest a drinks tray or magazine. The stool itself was easy to make, using blocks of chunky timber for its four legs and a circular disc cut from MDF for the top. The side support around the disc of MDF was made from flexiply; this holds the pouffe securely on the stool and prevents it slipping off to the side. Flexiply is a great product but quite expensive: try to buy an offcut for a small project like this. Alternatively, you could use a strip of thin hardboard: heat it carefully with the steam from a boiling kettle before working it around the circular base.

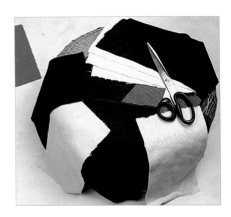

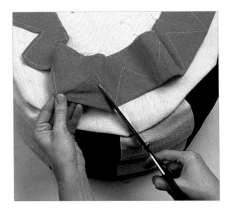

1 Measure the circumference of the pouffe and divide this into ten (the number of bands around the pouffe). Add 4cm (1½in) to the width of each band for the seam allowances. Measure the depth of the pouffe and add 4cm (1½in) to this. Next cut out five strips of black and five strips of white fabric following these measurements.

2 Place alternate-coloured strips together and sew down each long side leaving a 2cm (¾in) seam allowance to make a striped cylinder of fabric. Fit the cylinder over the pouffe. Measure the diameter of the top of the pouffe. Cut two circles of white fabric 4cm (1½in) larger than the diameter and place one over the top of the pouffe, folding the raw edges to the inside. Cut a piece of pink fabric 15cm (6in) wide and the length of the circumference of the pouffe. Fold this in half across its length and mark in pencil a regular pattern of zigzags. Stitch along the drawn lines, then cut away the fabric between each point.

3 Turn the zigzag strip right side out and press flat with a warm iron. Insert the raw edges of the strip between the raw edges of the circular band and the top disc of fabric on the pouffe. Pin along this edge, tucking in the raw edges as you progress. Hand stitch the edge once it has been pinned. Turn the pouffe upside down and attach the second circle of white fabric in the same way, but without inserting a zigzag edge. Remove the pins.

4 Cut a disc of MDF equal to the circumference of the pouffe plus 2.5cm (1in) all round. To do this, measure the diameter of the pouffe and divide this in half to get the radius. Cut a piece of string and make a loop at each end; the string should be equal to the radius plus 2.5cm (1in). Hammer a nail in the centre of the MDF, loop the string over the nail and insert a pencil in the other loop. Keeping the string taut, draw a circle.

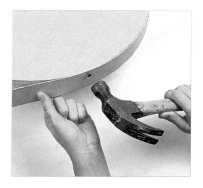

5 Using a strong craft knife and a steel ruler, cut a 5cm (2in) strip of flexiply to the length of the circumference of the MDF disc. Attach the strip to the outside edge of the MDF by hammering flat-headed tacks at intervals around the strip through to the MDF. The strip should be flush with the underside of the MDF, but project about 4cm (1½in) above the top surfaces.

6 Draw a straight line across the underside of the MDF crossing the centre point. Dissect this line with a second line at right angles to the first, also crossing the centre point (check the angles against the square corner of a sheet of paper). Cut four 10cm (4in) blocks of 7.5x7.5cm (3x3in) timber for the legs and glue these over each drawn line. Leave to dry.

7 Turn the stool over and screw long wood screws into each leg to secure. Paint the stool with a grey emulsion undercoat, then, when dry, apply a coat of black emulsion. Allow to dry, then varnish. When dry, place the soft pouffe on the base.

Floor lamp

I was thrilled to find such a splendid lamp base with its intricate twists and curls of metalwork in a local junk shop. This style of standard lamp does not appear in junk shops very often, so if you do see one, snap it up. Some of the more upmarket establishments (often described as antique shops) may stock them, but their prices tend to be a little inflated.

Electrification on this sort of lamp is not difficult: mine simply needed a new cable. The bulb holder was working perfectly, although these should be changed if cracked or damaged. If you can find it, use the modern equivalent of the twisted cotton corded flex, which looks so much better than trailing plastic cable on an old lamp. With careful preparation and a little loving care and attention, any metal lamp like this can be transformed into a glorious piece for your living room. The metal lamp base and shade were in a really tatty state when I bought them. The base was given a completely new look with fake silver gilding and the lampshade frame was stripped and recovered in creamy parchment.

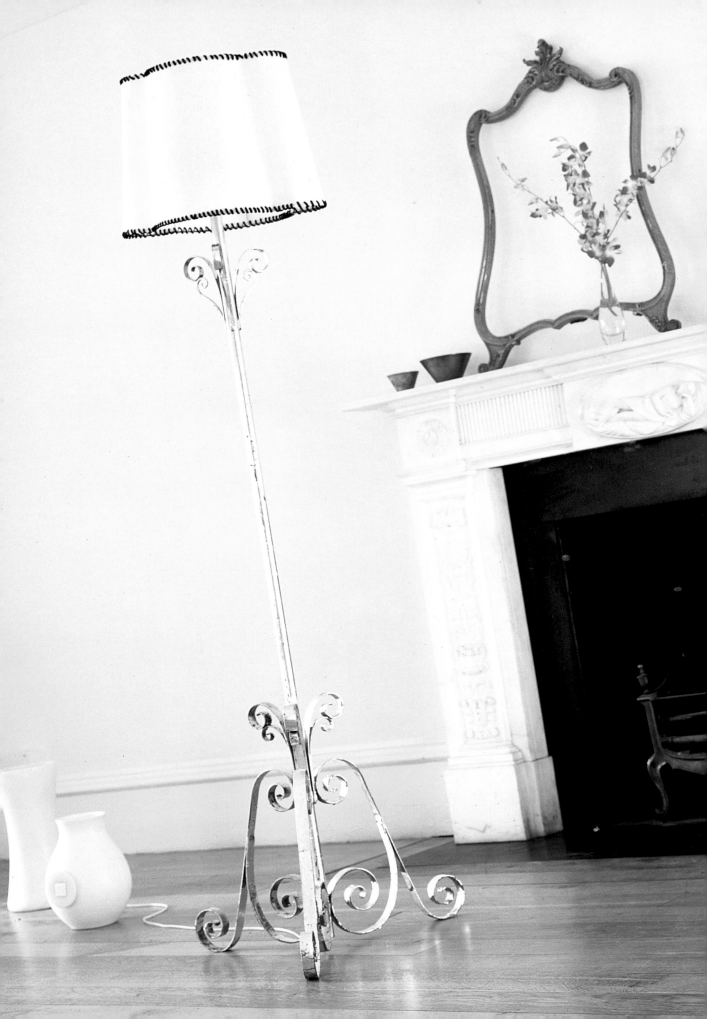

MATERIALS

metal lamp base and shade
red metal oxide primer
acrylic gold size
aluminium or Dutch metal
 transfer leaf
brown paper
parchment paper
black bootlace or string

EQUIPMENT

scraper
electric drill
wire brush
protective eye goggles
small household paintbrushes
scissors
pencil
matt adhesive tape
bradawl

TREATMENT With any metal work you need to spend time on the preparation. Hours of rubbing down with a wire brush can be significantly shortened if you use a wire brush fitted to a power drill. These are readily available at most DIY outlets: simply tighten into the chuck as you would any drill bit and operate at the normal speed. I used a narrow brush which enabled me to access the tight coils of the metalwork. Once all the flakiness and rust is removed it is important to prime metal before any further paint is added. I used a red oxide primer, a coat of which will prevent any rust from reforming. Silver or gold leaf can be used for the lamp base, or you may prefer the slightly cheaper options of aluminium leaf or Dutch metal leaf which look almost like the real thing.

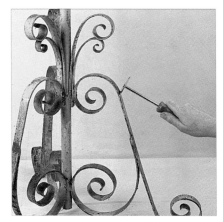

1 Scrape any loose, flaky bits of rust and metal from the lamp stand using a scraper. Concentrate on the large flaky areas only, as the wire brush will take care of the rest.

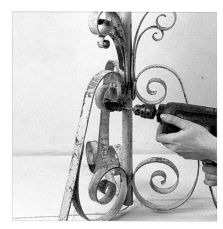

2 Using the wire brush attachment on an electric drill, follow the profile of the curling metalwork carefully, making sure that every curl has been covered. Wear goggles to protect your eyes from bits of flaking rust.

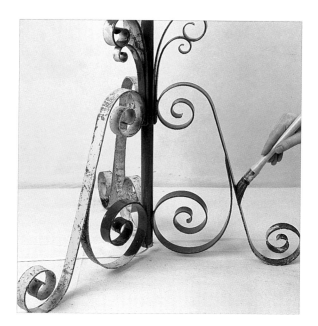

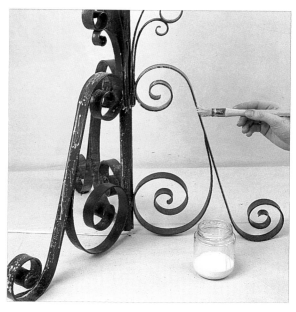

3 Paint on a coat of red metal oxide primer using a small household brush. Ensure every surface of the base is covered otherwise the rust will soon start to creep back through.

4 Once the primer is dry, brush on a layer of acrylic gold size. Work on one section of the lamp stand at a time as the size dries quite quickly.

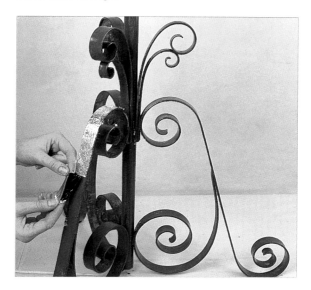

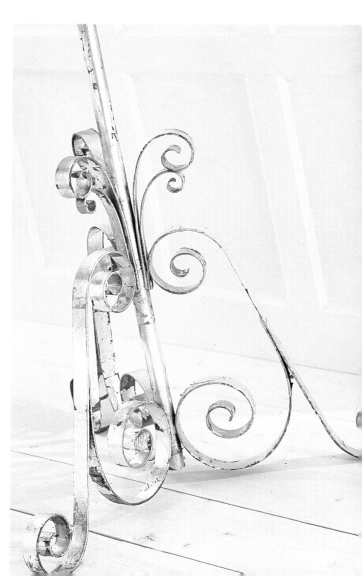

5 Test the size regularly and when this is just slightly tacky it is ready to be gilded. Cut the single sheets of transfer leaf into thin strips, wide enough to cover the metal curls. If you are using loose leaf, cut each strip with a knife and gently hold the leaf over the area to be covered, then press into place. Continue until the lamp base is completely covered.

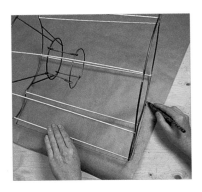

6 Strip the old covering from the lampshade, and clean up the skeleton frame.

7 Lay the frame on a sheet of brown paper and roll it across the paper, marking the top and bottom edges as you progress.

8 Place the pattern over the parchment paper, hold in place with matt adhesive tape, and cut out the parchment paper. If the shade is wide as this one was, cut two halves of parchment to cover the shade, allowing a small overlap at the joins and tape.

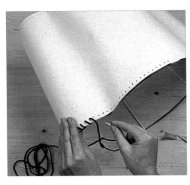

9 Use tabs of matt adhesive tape to hold the parchment shade on to the wire frame, paying particular attention to any curved sections. Punch evenly spaced holes along the top and bottom edges with a bradawl and use a black bootlace or string to bind the parchment to the frame, knotting the laces neatly at the back of the shade. Remove the tape.

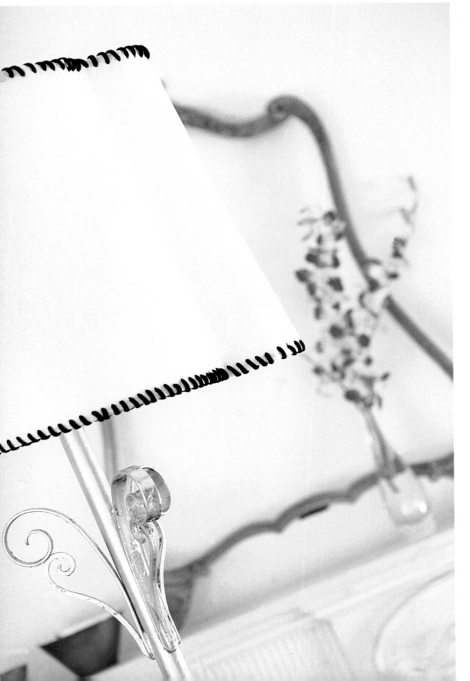

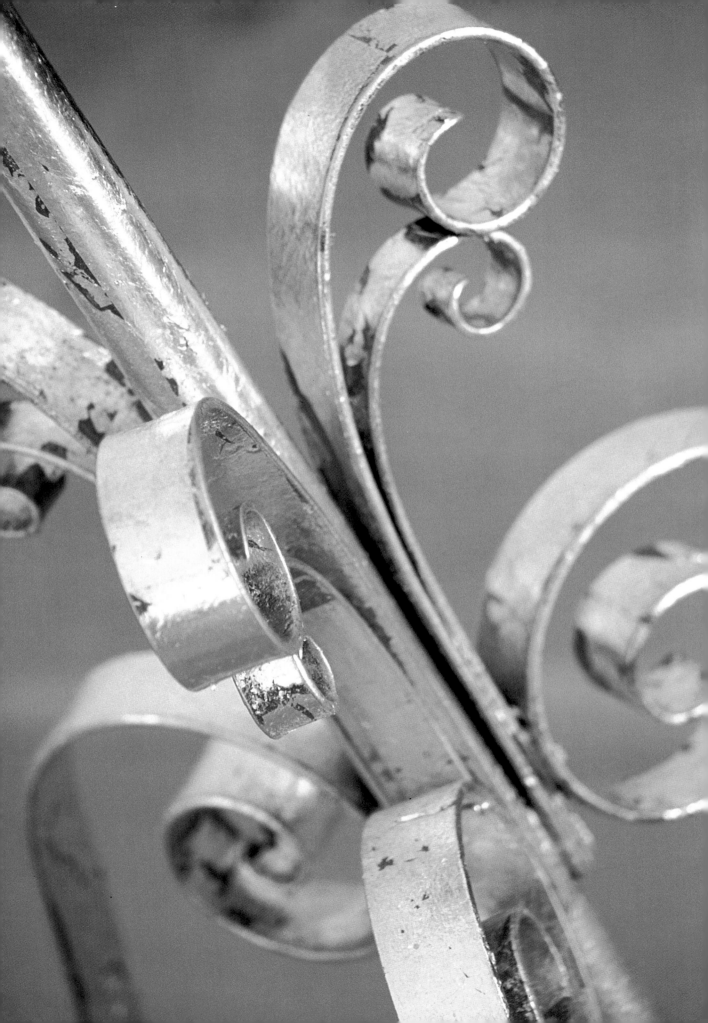

The
BEDROOM

Linen cupboard

Single wardrobes like this one can be found in lots of junk shops, so don't let anyone fool you into spending lots of money for a similar piece. I love the proportions of this wardrobe, which is perfect for changing into a tall linen cupboard and adding deep shelves from top to bottom. The simple architrave moulding around the top of the cupboard gave just enough detail to be elegant without being fussy, and the wooden handle suited the wardrobe so well that I didn't need to think about changing it. The panelled door offered me two easy shapes for cutting out with the jigsaw. The thinner centre sections of the panels were made from plywood, and offered little resistance to the jigsaw, so all in all it was a fairly straightforward cupboard to work on.

The inside of this cupboard was the focus of the decoration. A traditional fabric of blue hydrangeas lines the shelves and delicate fretwork panels were added to the edges.

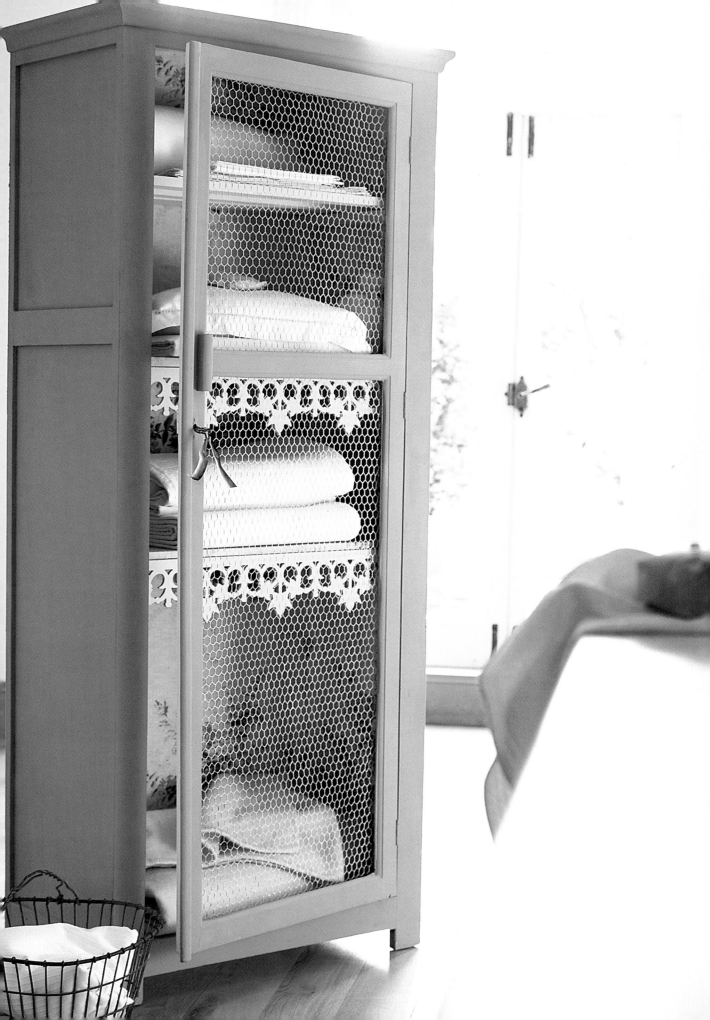

MATERIALS

old wardrobe
white acrylic primer
E.S.P.
turquoise emulsion paint
PVA adhesive
fabric to cover inner cupboard
chicken wire
fretwork edging
ivory emulsion paint
long tacks
grosgrain ribbon
thumb tacks
acrylic varnish

EQUIPMENT

electric drill and wide drill bit
jigsaw with wood-cutting blade
medium-grade sandpaper
household paintbrushes
cloth
tape measure
scissors
wire cutters
staple gun and staples
handsaw
bradawl
hammer

TREATMENT Once the panels were jigsawed out and opened up, the cupboard immediately changed focus for its decoration. It was the spacious inside of the cupboard that became the most important part for decorating. A cupboard that is destined for storing only delicately coloured linens, sheets and blankets can afford to be more extravagantly decorated inside. I chose to use a traditional linen fabric, printed with blue hydrangeas to cover the back of the cupboard. The fabric also covered the surface of the shelves, with the exception of the uppermost slatted shelf which was painted in a classic ivory colour to match the delicate, fretwork shelf edges. I chose one of the brighter colours in the fabric to use as my base colour for the exterior of the cupboard.

1 Use a wide drill bit on an electric drill to puncture holes into the four corners of each panel of the cupboard. Make sure that the drilled holes are wide enough to allow the jigsaw blade to pass through easily.

2 Fit the jigsaw with a wood-cutting blade and slot the cutting edge through one of the pre-drilled holes. Cut around each panel of the cupboard, keeping the edge of the blade in line with the edge of the panel for a neat straight edge.

3 Using a medium-grade sandpaper, rub down the rough edges left after cutting out the panels, carefully smoothing away any splinters that the jigsaw may have snagged on the wood. Work from both the inside and the outside of the door for an even finish.

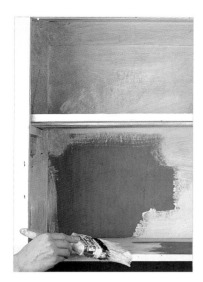

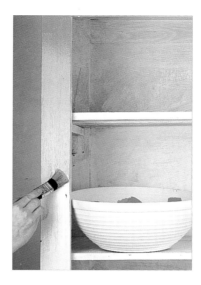

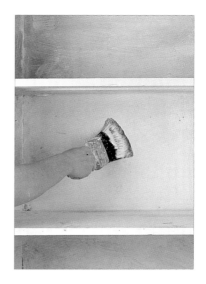

4 Paint the inside of the cupboard, including the shelves, with a coat of white acrylic primer. This will prevent the dark wood showing through the fabric when it is glued in place. Allow the paint to dry.

5 Prepare the exterior surface of the cupboard for painting. Then paint the prepared surface with two coats of turquoise emulsion paint, allowing the first coat to dry before applying the second. Leave to dry.

6 Starting with the back sections of the cupboard and working downwards on one section at a time, brush PVA adhesive over the dried primer inside the cupboard.

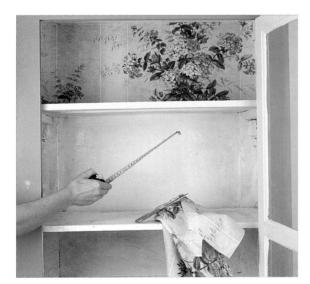

7 Measure the area to be covered and cut out the fabric accordingly. Stick the fabric in place and smooth it down. Don't worry about turning raw edges under or allowing extra fabric for overlapping, as the PVA will seal the raw edges; PVA also dries clear so any glue that seeps on to the front of the fabric will not be visible when the cupboard is finished. Repeat the covering process on the cupboard sides.

8 Once the back and sides of the cupboard are covered, cover the shelves in the same way. If you have had to make new shelves or if they are removable, take them out of the cupboard. If the shelves are fixed in position cover them *in situ*. Apply PVA adhesive over the top of each shelf, and along half of the underside, then stick the fabric in place, allowing for a large overlap to cover the underside of the shelf.

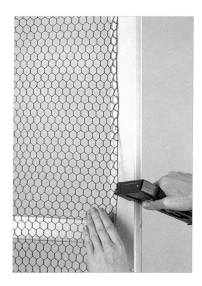

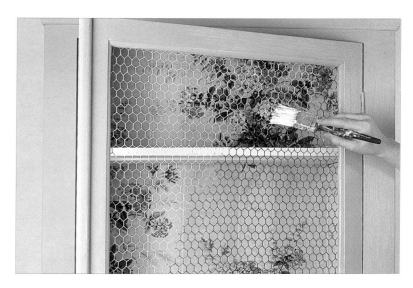

9 Using wire cutters, cut a strip of chicken wire to fit the cupboard door. Staple this to the top edge inside the door, then work down the two long sides, pulling the chicken wire slightly as you do so to prevent it sagging. Finally, staple along the bottom edge.

10 Brush white acrylic primer over the chicken wire first from the inside of the doors, and then from the outside. Avoid overloading the paintbrush and apply the paint carefully to minimize any splattering which might spoil the fabric covering.

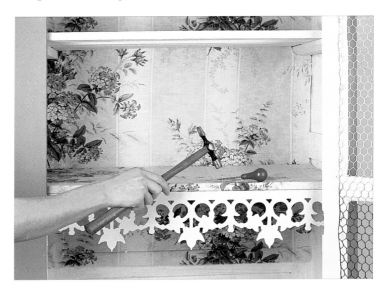

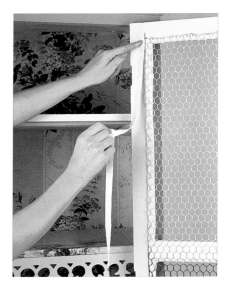

11 Using a handsaw, cut pieces of detailed fretwork edging to fit the cupboard shelves. Paint these all over with a coat of ivory emulsion paint and leave to dry. Make small holes along the top front edge of each shelf with a bradawl. Fix the fretwork edging in place by hammering long tacks down through the small holes.

12 Cut pieces of grosgrain ribbon to cover the wire edges inside the cupboard door. Brush a generous layer of PVA adhesive on to the wrong side of each piece of ribbon and stick in place over the edge of the chicken wire. Hold the ribbons in place with thumb tacks while the glue is setting; these can be removed later. Finally, varnish the exterior of the cupboard for protection.

Stencilled chest of drawers

Anyone would be forgiven for overlooking this rather boring chest of drawers in a junk shop, yet, it is not without some potential. I particularly liked the solid wooden construction and the drawers were unusually blessed with a smooth gliding action, a phenomenon that is rare in junk-shop finds. There was also the bonus of the surface needing little preparation work.

Chests of drawers tend to be fairly inexpensive in junk shops, usually because there are so many of them. However, do search for real 'junk' pieces rather than chests masquerading as junk. Occasionally I have spotted some rather lovely chests of drawers that would simply benefit from a little re-conditioning rather than a coat of paint. If in doubt, chat to the shop owner about the origins of the piece of furniture.

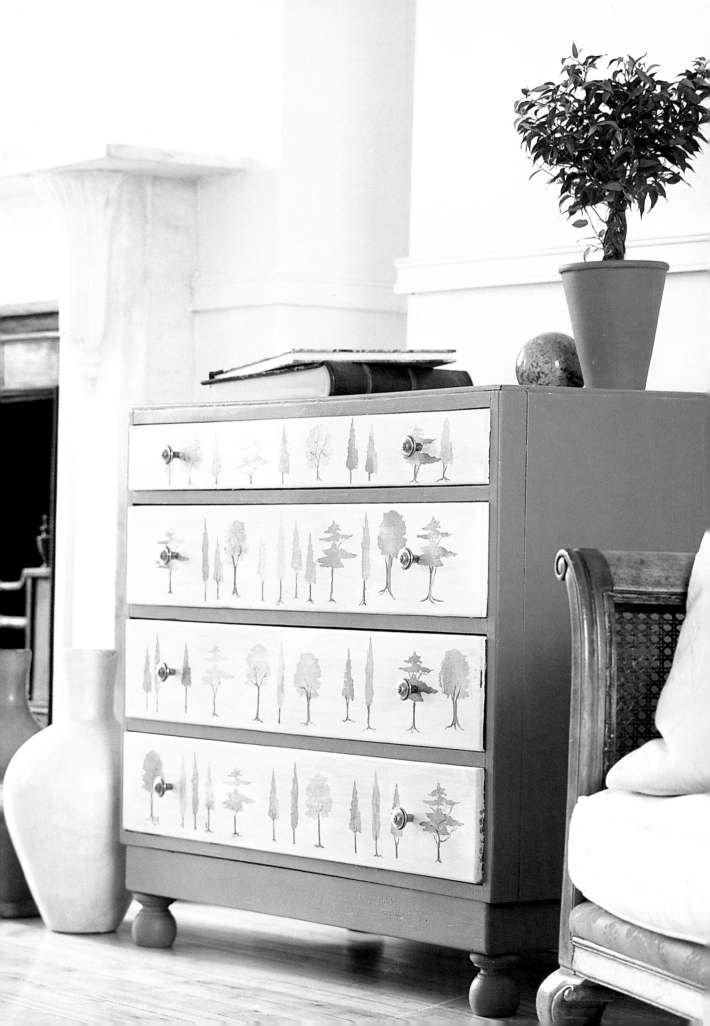

MATERIALS

chest of drawers
wood filler
dark green emulsion paint
ivory emulsion paint
tracing paper
stencilling acetate
spray adhesive
light green acrylic colour
dark green acrylic colour
brown acrylic colour
burnt umber acrylic colour
acrylic varnish
replacement handles and screws
4 pine bun feet
white acrylic primer
long wood screws

EQUIPMENT

screwdriver
scraper
fine-grade sandpaper
household paintbrushes
pencil
cutting mat
craft knife
stencil brush
artist's brush
bradawl
electric drill and bit
countersink bit

TREATMENT The long rows of forest trees made an appealing decoration for this chest of drawers. From the four tree stencil outlines provided at the back of the book you can make up your own sequence of trees on each drawer; it is a simple technique requiring only basic stencilling knowledge. The trunks and branches were painted in freehand, using elementary painting skills. You could add as many or as few branches or tree roots as you wish. Four pine bun feet were added to give the chest a little extra height and a slightly more attractive look; feet of this type are readily available from hardware and DIY stores.

1 Remove the handles from the chest and fill the old holes with a little wood filler. Smooth the filler when dry with fine-grade sandpaper, then fill again if the dry filler is not flush with the surface of the wood.

2 Rub the chest with fine-grade sandpaper to provide a key. Then apply a coat of dark green emulsion paint to the carcass of the chest; allow to dry, then apply a second coat. Next paint a coat of ivory emulsion across each of the four drawer fronts; when dry, apply a second coat. Leave to dry.

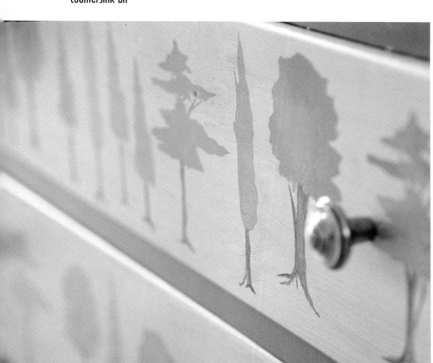

3 Trace the tree templates supplied at the back of the book, then transfer the tree designs on to stencilling acetate. Place the acetate on a cutting mat to protect the underlying surface and cut out the shapes with a craft knife.

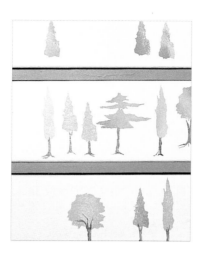

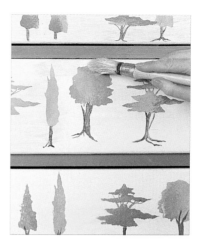

4 Apply spray adhesive to the back of each stencil in turn and place it on the drawer front. Using a stencil brush, apply a combination of light and dark green acrylic colours through the stencil to create the tree canopies. Repeat the process with the other stencils, blending the colours differently each time.

5 Paint in the trunks and branches of the trees using an artist's brush and brown acrylic colour. Use this picture as a guide or make up your own trunk shapes as appropriate. Vary the brushstrokes to create interest in the paint, allowing the colour to be at times thin and at other times dense.

6 When the paint is dry, mix a little burnt umber acrylic colour into some acrylic varnish to tint it slightly. Brush the varnish over the chest of drawers, allowing it to look streaky in places to create an interesting finish. Allow the varnish to dry.

7 Screw a pair of new handles on to each of the drawers. If you are using the existing holes, use a bradawl to push the filler out of the old holes first; alternatively, drill new positions for the handles from the inside of the drawers.

8 Paint the pine bun feet with white acrylic primer, then two coats of dark green emulsion, allowing each coat to dry before applying the next. Finally, add a coat of varnish and allow to dry. Drill and countersink a hole though each bun foot. Screw a long wood screw in the hole and into the framework of the chest of drawers. If necessary, use two screws for a secure fixing. Repeat on the remaining three corners.

Children's storage unit

This rather ancient-looking cupboard was exactly what I had been looking for to make a children's storage unit. The cupboard was very solid and contained plenty of useful shelving, which was perfect for stacking books, games, clothes, blankets and other childhood paraphernalia. A pull-out shelf situated in the cupboard at knee height was the ideal place for the storage of socks and tights, and accessible enough for children to reach these items themselves. The deep space underneath the shelf cried out to be filled with a toy chest that could be pulled out when needed, then pushed away when not. I loved it! All I had to do was get rid of the brown wood and make the unit instantly appealing to the children for whom it was intended.

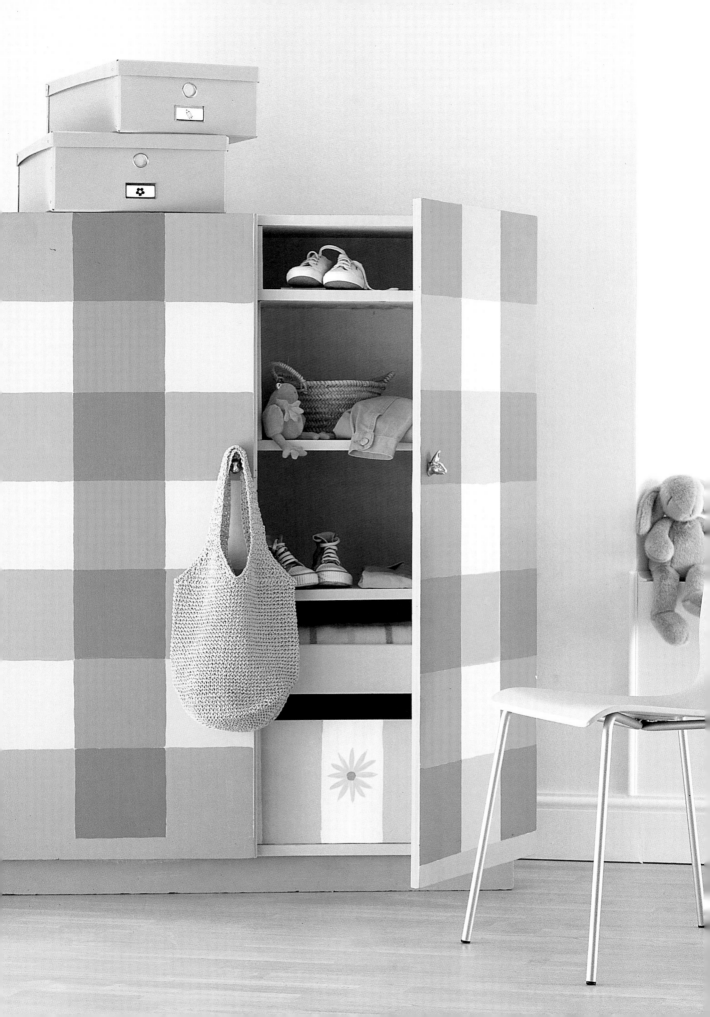

MATERIALS

cupboard
dark pink emulsion paint
white emulsion paint
acrylic varnish
MDF, 6mm (¼in) thick
4 pieces of 2.5x2.5cm (1x1in)
 timber
wood screws
E.S.P.
lime green emulsion paint
replacement handle and screws

EQUIPMENT

household paintbrushes
mixing pots or paint kettles
pencil
long ruler or straight-edged
 timber
tape measure
fitch brush
artist's brush
jigsaw
sandpaper
electric drill and bit
countersink bit
cloth
decorator's masking tape
screwdriver

TREATMENT I decided to give the cupboard a lift with a gingham paint effect. Although this sounds quite daunting, it really is quite simple. You don't need vast quantities of colour, just a dark pink and a regular white emulsion. From these two paints you make up your own palette of dark pink, medium pink, pale pink and lighter pink: add to that a lime green and you have got a palette that will set a child's heart racing.

The size of the gingham squares will be determined by the size of your cupboard, but always aim for large ones. I used three squares across each door, which gave me seven squares down the height of the cupboard with just a little sliver extra which I lost, visually, at the bottom of the doors.

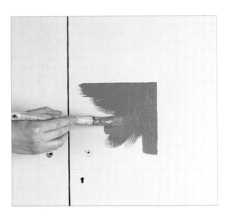

1 Prepare the cupboard for painting using E.S.P. (see page 127). Mix up four separate pink colours, mixing enough paint to complete the job. Apply the medium pink over the entire cupboard; when dry, apply a second coat if necessary. Leave to dry, then mark the squares using a tape measure, a long straight edge and a pencil.

2 Paint the darkest pink squares using a pointed fitch brush which will enable you to paint neatly up to the pencil lines and squarely into the corners.

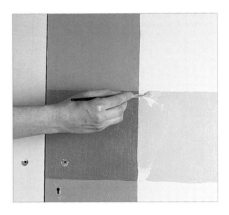

3 Allow the paint to dry, then fill in the medium pink squares, painting directly above and below the darkest pink squares. Leave to dry.

4 Finally, using a small artist's brush to enable you to reach into tight corners, paint the pale pink squares to the left and right of the darkest pink squares. Now you will see the characteristic gingham pattern taking shape. When dry, varnish the exterior of the unit.

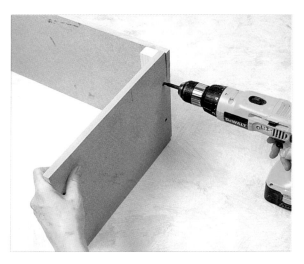

5 Using a jigsaw, cut pieces of MDF to make up the toy chest. Measure the depth and width of the available space in the cupboard, then reduce the measurements by 5cm (2in) at each side, and at the front and back, to allow for an easy fit. Cut four sides accordingly. Then cut four pieces of 2.5x2.5cm (1x1in) timber to 2.5cm (1in) less than the depth of the chest. Smooth all the rough edges with sandpaper.

6 Fix the timber blocks against the edge of the shortest sides of the chest, keeping one edge of the timber flush with the top edge of the MDF. Pre-drill pilot holes, then countersink and screw the timber pieces to the MDF. Hold the long MDF sides against the short sides and pre-drill, countersink and screw each corner in turn until the sides of the box are fixed together. Turn the chest over and cut an MDF base to drop inside and rest on the timber supports which are 2.5cm (1in) below the bottom edge of the chest. Screw the base into the timber supports as before, to complete.

7 Prepare the interior of the storage unit with E.S.P. (see page 127), then apply a coat of lime green emulsion paint. Mask striped areas down the front of the toy chest using masking tape, then paint the chest with lime green emulsion. Apply a second coat when dry.

Remove the masking tape from the chest and paint these stripes with white emulsion paint. When the paint is dry, paint a daisy motif at the centre of each stripe using lime green and pink emulsion. Allow to dry. Varnish the box and the interior of the cupboard for protection. Screw a new handle on to the unit's door.

Child's bed

Even I almost threw the remains of this bed away, thinking there was nothing to be done with them. The dull base and the boring head and tail boards looked sadly uninspiring. However, on closer inspection, I realized that the head and tail boards were made of wood, and did not get in the way of the mattress, which meant that I could simply add shapes on to the four corners. I decided to add chunky timber posts to elongate the sides of the frame and make a wonderful, mini four-poster bed. The flower pots on top of each post were inspired by simple childlike drawings of flowers, and are made up from two flat pieces of MDF that are slotted together like a puzzle, to make a three-dimensional shape.

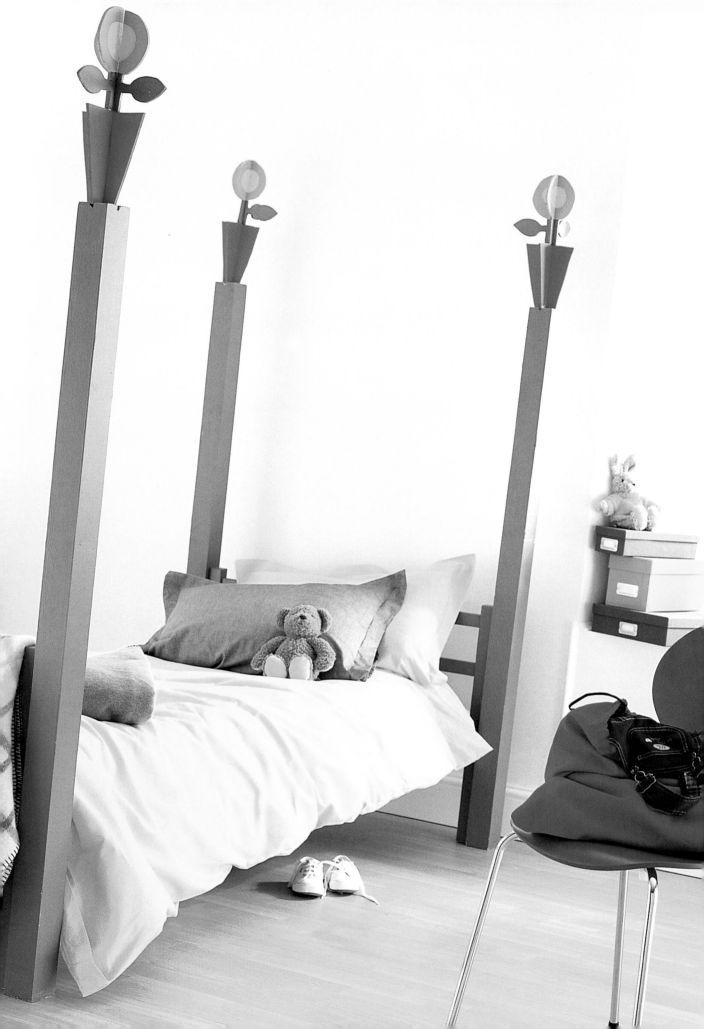

MATERIALS

bed with head and tail boards
 and mattress
four 7.5x7.5cm (3x3in)
 timber posts, 135cm (54in)
 high
long wood screws
wood filler
white acrylic primer
blue emulsion paint
acrylic varnish
flower pot motifs
tracing paper
MDF, 3mm (⅛in) thick
red, green, pink and yellow
 acrylic colours
wood glue
panel pins, if necessary

EQUIPMENT

electric drill and drill bits
countersink bit
screwdriver
scraper
sandpaper
cloth
household paintbrushes
photocopier
pencil
jigsaw with narrow profile blade
tenon saw
hammer, if necessary

TREATMENT I wanted to use strong colours for the bed but not necessarily primary colours which would have been too contrived. The strong blue, red, green and yellow that I did use all have the 'garish' primary quality knocked out of them by simply adding a dash of a complementary shade: a blob of orange in the bright blue for instance, or a dollop of red in the green. This mixing of colours dulls the intensity of strong tones, making them a little more uplifting.

You can either mix the colours yourself, if you already have colours to play with, or you can simply choose the colours from a paint chart bearing this in mind.

1 Hold a timber post against the side of the wooden bed head and pre-drill three pilot holes to take the screws that will secure the post to the bed. Countersink each hole and use long wood screws to fix the post in place.

2 Fill the holes with wood filler. Allow to dry, then sand the filler smooth. Repeat steps 1 and 2 to attach the three remaining posts to the bed frame, ensuring that the bases of the posts align exactly with the bottoms of the legs so that the bed does not wobble.

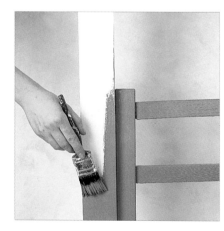

3 Apply two coats of blue emulsion paint over the posts and the bed frame, allowing the first coat to dry before applying the second. When the second coat is dry, apply a coat of acrylic varnish to seal and protect the painted surface.

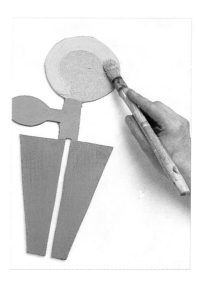

4 Enlarge the templates at the back of the book using the appropriate facility on a photocopier. You will need two shapes for each flower pot. Using tracing paper, transfer the flower pot outlines on to MDF. Shade in pencil the slots to be cut out with a jigsaw.

5 Using a jigsaw fitted with a narrow profile cutting blade, carefully cut out two flower shapes for each pot, making a total of eight shapes for the four posts. Sand the rough edges smooth. Slot the shapes together to make sure they fit correctly, making adjustments where necessary.

6 Paint the cut-out shapes on both sides with a combination of acrylic colours and allow to dry. I used red, green, pink and yellow, but you can vary the colours to suit your decor. You may need to apply a second coat of the paler colours. When dry, apply a coat of acrylic varnish.

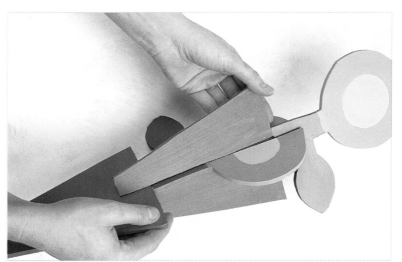

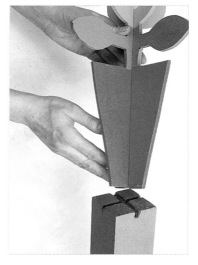

7 Slot the finished flowers together and squeeze a little PVA adhesive into the joint to keep each flower shape secure. Allow to dry, when the adhesive will turn clear and become invisible.

8 Cut a cross into the top of each of the four bed posts using a tenon saw. Each slot should be wide enough to fit the bottom of the flower pot snugly; the depth should be enough to prevent movement of the pot. Paint the slot blue; then, when dry, squeeze in enough wood glue to make a firm fixing. Slot the flower pot in position and leave to dry. If necessary, tap in panel pins for extra security.

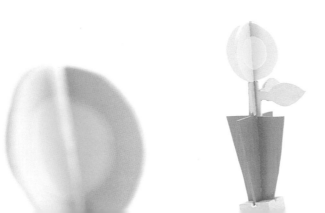

Upholstered chair

Typical of many chairs found at the back of dusty junk shops, this chair was in a very sorry state when I found it. The upholstery was dirty and worn and the stuffing needed replacing. However, the frame was sturdy and the chair had potential for improvement. Do make sure you sit on a chair before committing yourself to buying it. A lumpy base indicates damage to the springs underneath and this type of neglect requires more than a simple re-upholstery job. So, unless you are prepared to strip the chair back to its basic wooden frame I would be tempted to leave such a challenge to those with more time on their hands. Presuming the seat is in a reasonable condition, however, check for a stable frame. Make sure that the legs are even; it surprises me how many are wobbly. A chair that rocks when you sit on it indicates a problem – unless of course it is supposed to rock. If this basic checklist fails to turn up any problems then you will have found something worth renovating.

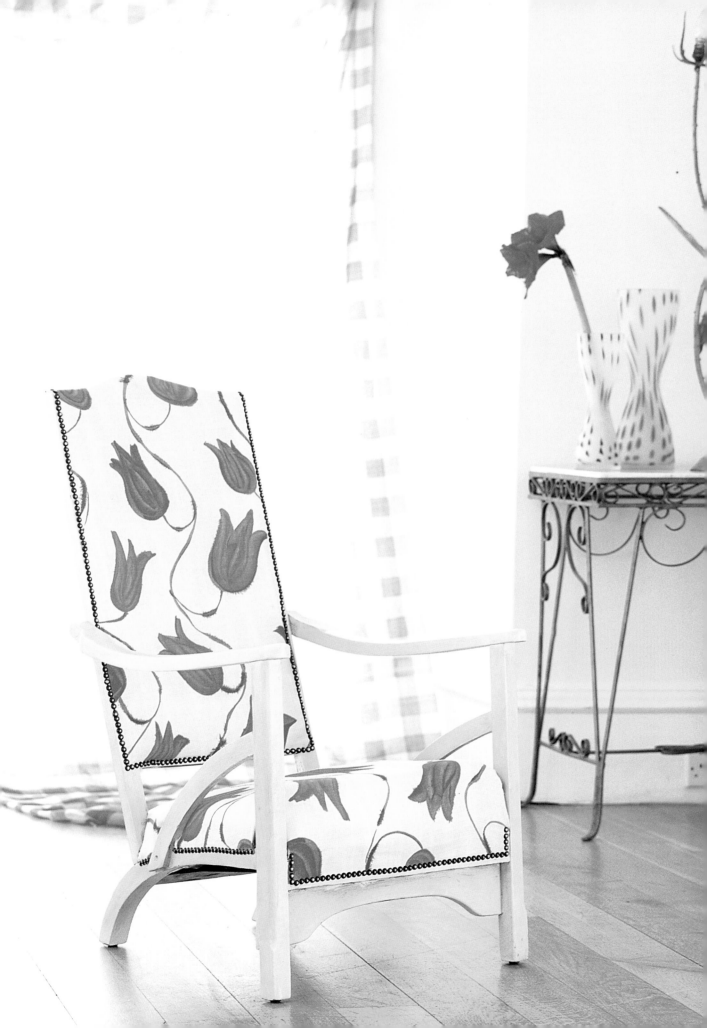

MATERIALS

upholstered chair
newspaper
white acrylic primer
ivory emulsion paint
dark oak buffing wax
upholstery fabric
wadding
lengths of upholstery tacks
brown paper

EQUIPMENT

claw hammer
medium-grade and fine-grade
 sandpaper
power sander, if necessary
soft cloths
fitch brush
tape measure
dressmaking scissors
staple gun and staples
pins

TREATMENT This bold. printed fabric was my starting point for the chair. It is a designer fabric. but for a chair like this. you will often need less than a metre of fabric for re-covering it. so it can be worthwhile using a little of an expensive fabric. However. if you are keeping to a budget it's worth keeping a look-out for remnants or end-of-roll pieces that are usually sold at a reduced price. Most good fabric suppliers will have a remnant bin in which you can find glorious fabrics often at less than half price.

Upholstery tacks make a neat tailored finish to upholstery but can be fiddly to hammer in a straight line: the tacks I use are supplied as a long strip with only every fifth tack being a real one.

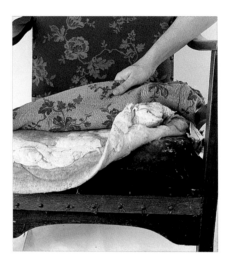

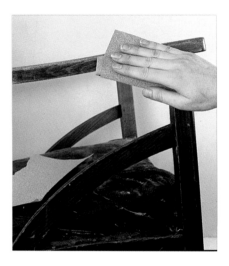

1 Working outside or on newspaper to protect your floor from dust, strip away the original fabric covering on the chair and the backrest, right back to the wadding underneath; if this is particularly dirty, then I would recommend that you dispose of this too, stripping the seat back to the canvas. Remove all old upholstery tacks with a claw hammer.

2 Sand back the wooden frame using first a medium-grade sandpaper then a fine-grade one. To remove a heavy lacquered finish you may need to use a power sander; choose a 'delta' sander for preference to access tight corners.

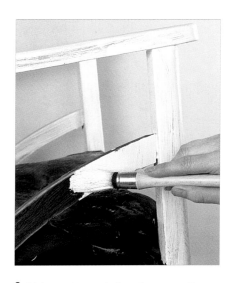

3 Using a damp cloth, wipe away the dust left by sanding, then apply a coat of white acrylic primer. You will find it easier to use a pointed brush when painting the narrow parts of the frame. Turn the chair upside down to paint underneath. Allow to dry.

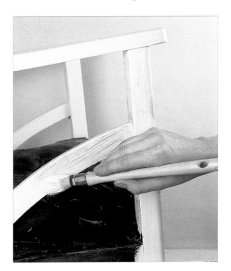

4 Using the same brush, apply two coats of ivory emulsion paint, allowing the first coat to dry before applying the second. Paint underneath the chair too, keeping the painted line as close to the upholstered parts as you can.

5 Once the ivory emulsion is totally dry, rub dark oak buffing wax over the painted surface with a soft cloth. This enriches the colour of the emulsion and protects the surface rather like varnish.

6 To re-upholster the chair, first measure the widest part of the backrest and the distance from top to bottom, and add 5cm (2in) to these measurements. Cut out a piece of the patterned fabric following these measurements, remembering to follow the direction of the pattern. Staple the fabric to the frame so that the pattern faces out of the back of the chair, keeping the overlaps to the inside of the frame.

7 Cut three layers of wadding to fit the backrest, not allowing for overlaps. Staple the wadding to the chair frame to cover the first layer of fabric.

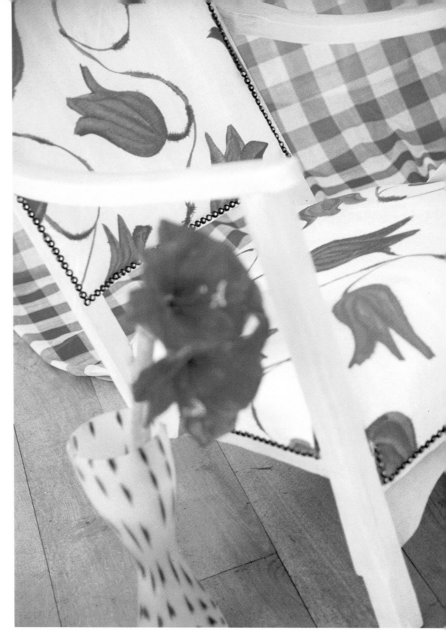

8 Cut out a top piece of fabric for the backrest, following the direction of the pattern. Pin this over the soft wadding, pulling it taut as you go. When it is correctly aligned, use the staple gun to fix the fabric to the frame. Keep the staples towards the edge of the frame.

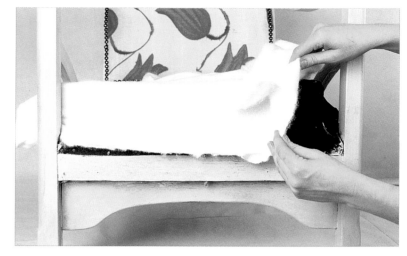

9 Cover the staples along the frame with lengths of upholstery tacks. Using these, rather than individual tacks, makes it easier for the beginner to achieve a neat, even row that looks just like the real thing. Every fifth tack is a real one that should be simply tapped in place with a small hammer.

10 Cut a double thickness of soft wadding the approximate size of the chair seat and fit this over the canvas seat cover. Tug the wadding tightly into the corners of the chair and cut away any excess. Secure the wadding to the frame with a line of staples.

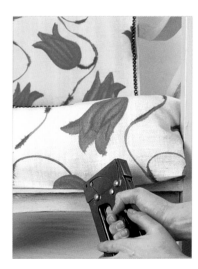

11 Using a piece of brown paper, make a template for the fabric covering. Lay the paper over the base of the chair and fold it over the sides of the seat, to work out exactly how the fabric would fit. Cut the paper where necessary, allowing a generous turning-under allowance. Pin the paper on to the fabric, following the direction of the pattern, then cut the fabric out.

12 Fit the fabric over the wadding, pulling it taut for a neat fit. Fold excess fabric into the corners and tuck it away neatly. Fold the raw edges of the fabric underneath then staple the fabric to the frame around the entire seat. To finish, cover the staples with lengths of upholstery tacks as in Step 9.

The BATHROOM

Bathroom seat

This reproduction coffee table, although unfashionably covered with thick brown varnish, was in very good condition with sturdy legs. Although I could easily have given it an interesting paint treatment and kept it as a table, I felt that the coffee table shape was perfect for a simple, bench-like, seating solution for the bath-room. The frame was strong enough to take an adult's weight, and with two supports at either side it could be trans-formed into an elegant seat in a matter of minutes.

The silvery grey paint effect chosen for the seat is reminiscent of driftwood; the two-part effect relies on a thin white top coat being applied in a streaky fashion over a more solid, grey base coat. The white both softens the grey and is held as a solid colour in the carved details on the table legs.

MATERIALS

table
two 5x15cm (2x6in) pine
 boards
long wood screws
newspaper
chemical varnish stripper
grey emulsion paint
white woodwash (or 1:1 mixture
 of white emulsion and acrylic
 varnish)
dense foam pad (available from
 foam suppliers)
fabric for cushion cover
sewing thread

EQUIPMENT

tape measure
pencil
jigsaw with long cutting blade
screwdriver
heavy-duty gloves
household paintbrushes
protective goggles
stripping knife
wire wool
medium-grade sandpaper
cloth
dressmaking scissors
pins
sewing machine
needle

TREATMENT The best way of stripping back thick varnish on a piece of repro-
duction furniture like this is to use a chemical wood stripper. This should be used with
great care as it is extremely caustic and can burn unprotected skin. Always wear thick
heavy-duty gloves and a face mask to protect the eyes from stray splashes. The waste
material that is scraped away should be disposed of carefully and never allowed to go
into the waste system; your local rubbish tip will take away such waste. Always read the
manufacturer's instructions on the container before you begin.

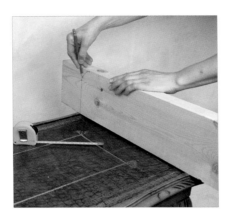

1 To make side supports for the bench,
place a pine block across the side of the
table. Measure and mark with a pencil
the positions to cut, then draw a curved
edge at the top of the block as a cutting
guide. Repeat with a second length of
pine. Cut out the pine supports with a
jigsaw. Attach the supports to the
bench by screwing long wood screws
through the table base from underneath,
into the supports.

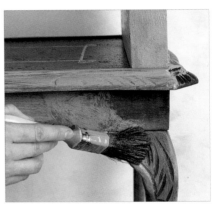

2 Wearing heavy-duty gloves and
protective goggles, and standing the
table on newspaper, strip the heavy
lacquer from the table using a chemical
varnish stripper and a stripping knife
(see page 126 for detailed instructions).
When the table is dry, apply a coat of
grey emulsion paint over the entire
table. Allow to dry, then apply a second
coat for an even coverage. Leave to dry.

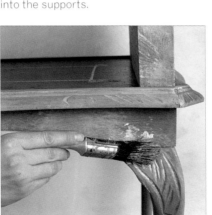

3 Apply white woodwash over the grey
base coat to create a patchy driftwood
effect. If you cannot find white wood-
wash, you can use white emulsion
diluted 1:1 with acrylic varnish for a
similar effect.

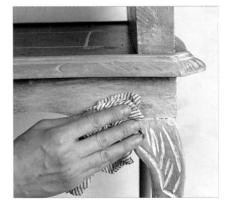

4 Without waiting for the woodwash to
dry, use a cloth to wipe it over the
carved details of the table to highlight
the build-up of white colour in the
recessed areas. Apply more woodwash
to build up the required effect.

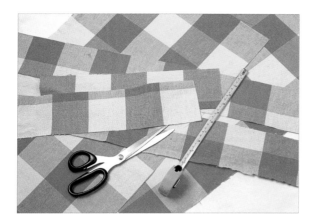

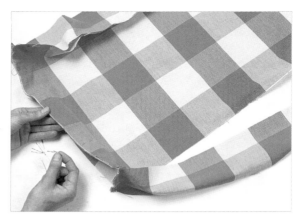

5 Measure the area of the seat to be covered with a cushion and buy a rectangle of dense seating foam to fit. To make a box cushion cover for the foam, cut out four side panels and a top and bottom section from checked fabric; these pieces should be 5cm (2in) larger all round than the measurements of the foam pad to allow for seams.

6 Taking a 2.5cm (1in) seam allowance, pin the pieces of the cushion together. Sew the seams of the cushion cover using a sewing machine, leaving one short seam open. Remove the pins.

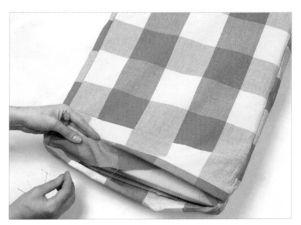

7 Turn the cover right side out and insert the foam pad. Hand stitch the gap closed. Place the cushion between the supports on the seat. The cushion can be washed when required; simply unpick the hand stitches then re-stitch when the cover has been cleaned.

Painted
washstand

I was on the look-out for a washstand when I spotted this rather stumpy unit, and was pleased to find that it had all the right credentials. The condition of the cupboard was good, and hardly any preparation would be needed prior to painting. The two cupboard doors featured simple mouldings, the interior was spacious and the height was just right. The legs, although ungainly in their dark wood state, were solid and strong. Finally, the overhanging top was perfect for fixing on a three-sided back section; I could simply screw on the new side pieces from underneath. I planned to trans-form the heavy dark wood front, which made the cabinet so dull, with plain white paint and a dramatic decorative motif, and tile the top to convert the cabinet into a washstand.

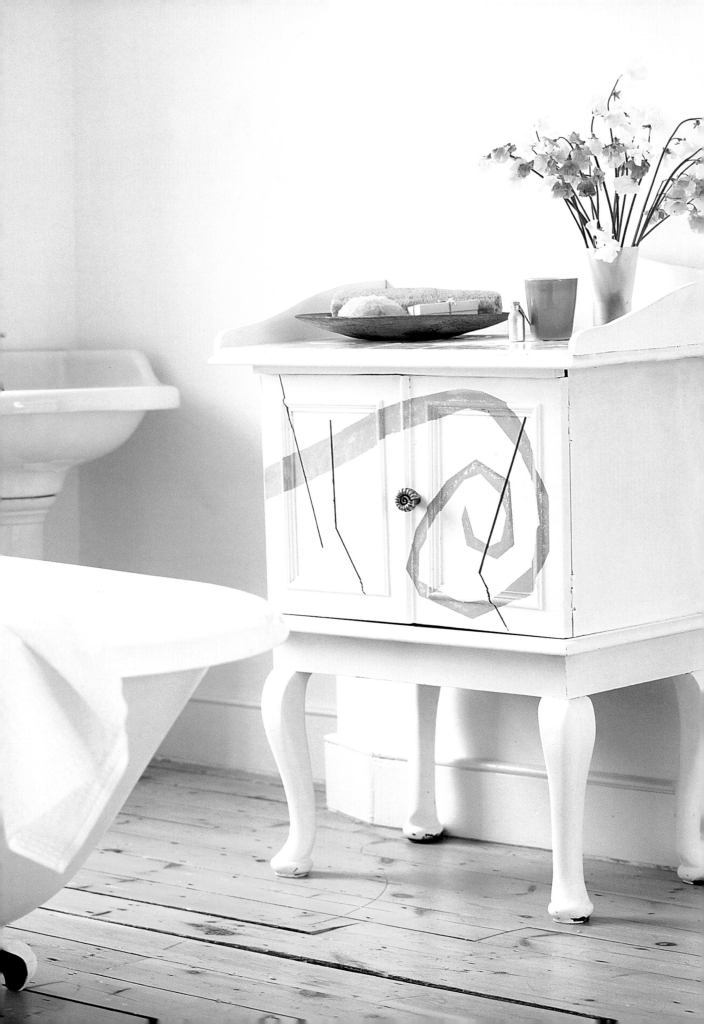

MATERIALS

cabinet
MDF, 6mm (¼in) thick
white wall tiles
wood glue
long wood screws
wood filler
white acrylic primer
white tile adhesive
tile spacers, if necessary
white emulsion paint
mid blue emulsion paint
dark blue emulsion paint
acrylic varnish
replacement handle

EQUIPMENT

pencil
tile cutter, if necessary
tape measure
jigsaw
medium-grade sandpaper
electric drill and bits
screwdriver
household paintbrushes
notched spreader
cloths
low-tack decorator's tape

TREATMENT Changing the appearance of a piece of furniture from dark to light is dramatic, but entirely justified in this case as I wanted to lose the cumbersome appearance of the cupboard. A bold, abstract design painted on to the white emulsion surface gave the cupboard a sleek, contemporary look. The white tiled top was easy to fit and miraculously, although it was more fluke than good judgement. I did not need to cut any tiles. If you have a unit that is not so accommodating, a tile cutter will make light work of cutting tiles to fit.

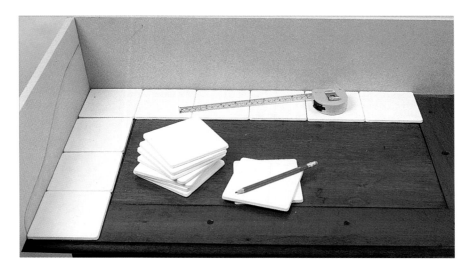

1 Position lengths of MDF around the sides of the unit top: a longer piece across the back and a shorter piece along one side. Determine the height of the back and the shape of the sloping sides and mark this on the MDF. The side sections will be symmetrical, so draw only one half as the other half is a carbon copy of this. Lay the wall tiles over the top of the unit to check the fit. If the tiles do not fit exactly, cut to fit with a tile cutter.

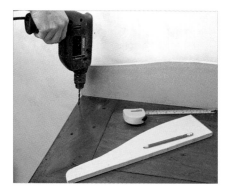

2 Remove the tiles and the MDF pieces from the unit and draw the shaped MDF sides more accurately. Cut out the resulting pieces using a jigsaw and smooth the cut edges with sandpaper. Pre-drill the holes needed to fix the MDF pieces on to the top, taking into account the thickness of the MDF.

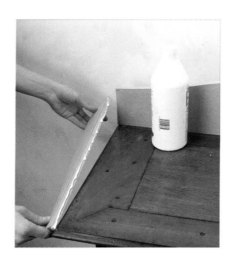

3 Apply wood glue along the edges of each MDF length in turn and position it glue-side down on the worktop. Screw through the underside of the unit top. into the MDF, using long wood screws slightly larger than the pre-drilled holes.

4 Fill the gaps between the back and side pieces of MDF with wood filler. You can ignore any irregularities on the top of the unit, as the tiles will cover these. When dry. rub the filler smooth with sandpaper. Then paint the entire cabinet with a layer of white acrylic primer and leave to dry.

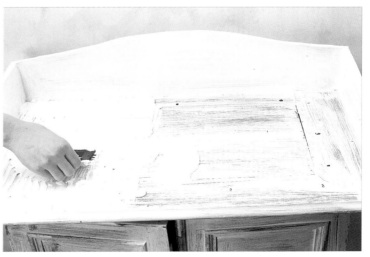

5 Apply white tile adhesive liberally over the top of the work surface and spread it evenly using a notched spreader.

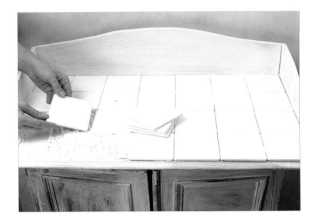

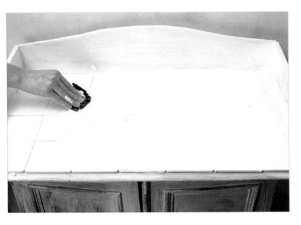

6 Press the tiles in the tile adhesive. On a small area like this tile spacers are not necessary; however, for a larger area, or if the tiles need cutting to fit, you will need to use spacers to keep the tiles evenly placed.

7 Apply more of the tiling adhesive over the tiled surface. Press it into the spaces between the tiles, pushing down evenly and firmly with the spreader. Make sure all the gaps are filled.

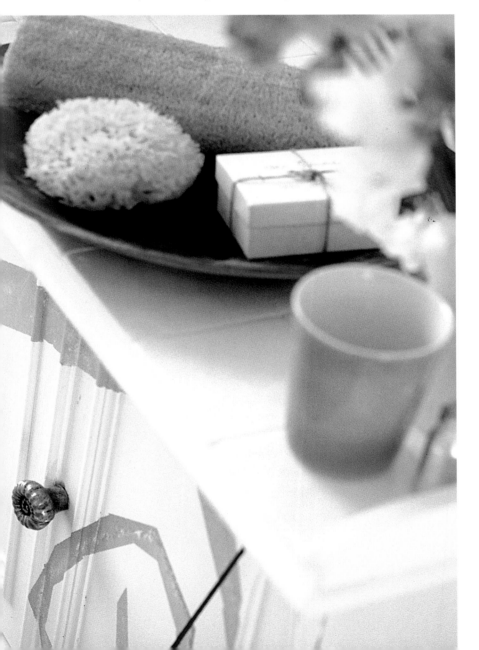

8 Wipe the excess adhesive from the surface of the tiles using a damp cloth. Rinse and wring out the cloth in cool water as often as necessary. Polish the surface with a clean damp cloth once the adhesive has been removed.

9 Apply two coats of white emulsion paint over the cabinet, allowing the first coat to dry before applying the second. When dry, tear pieces of low-tack decorator's tape and stick these in a spiralling shape across the front of the cabinet. Brush on a patchy layer of mid blue emulsion paint, then remove the tape.

10 Apply more torn pieces of tape on the inside of the spiral, making sure that the spiral becomes thinner as it twists around to the centre of its shape. Apply mid blue paint in the same way as before. Remove the tape to reveal a wider blue spiral.

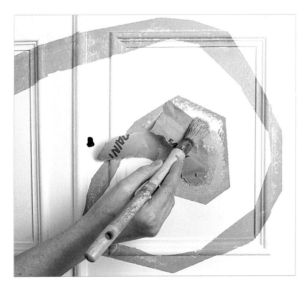

11 You may need to paint in the tight coil at the centre of the spiral after the second application of tape has been removed as the tape tends to overlap too much at the centre. Paint the centre, then remove the tape.

12 Using decorator's tape, mask off thin dart-like lines that cross the spiral pattern. Paint these lines with dark blue emulsion paint using an artist's brush. When dry, varnish the cabinet with two layers of acrylic varnish to protect against the humidity of a bathroom environment. Finally, fit a new handle to the washstand door.

Frosted glass cabinet

This lovely miniature cupboard was in a very sad state when it was purchased, being very dirty and entirely doorless, but, as it was such a charming and unusual shape and had such deep, useful proportions, I decided to buy it first then decide on a use for it later. One possible idea was to turn it into a cheese safe for the kitchen, adding wire mesh in the door frame and painting the entire cupboard a deep Shaker green. However, as I had recently discovered a 'fake' spray-on frosting for plain glass that is almost indistinguishable from the real thing, I wanted to use this technique so the cupboard was transformed instead into a unique frosted-glass cabinet perfect for using in a bathroom.

MATERIALS

small cupboard
wood glue
wood screws
white acrylic primer
cream emulsion paint
pistachio emulsion paint
safety glass, cut to size
glass cleaner
template for glass design
spray mount
paper
can of glass etch spray
wooden glazing bars
panel pins
acrylic varnish
new hinges, if necessary
replacement handle

EQUIPMENT

bowl for soapy water
cloth
glue brush
corner clamps, if necessary
screwdriver
household paintbrushes
tape measure
photocopier
craft knife
hammer

TREATMENT The cupboard was pretty grimy inside so it had to be thoroughly washed and scrubbed before any work could be done. Lots of warm soapy water was used and plenty of drying time was set aside before painting.

There are several types of fake frosted glass on the market but I find that the one that comes in a can is the best. If you have a problem finding the product, you can make your own frosting medium from an equal quantity of polyurethane varnish and white oil paint. Mix them together and stipple over very clean glass for an effect that is good, but not quite as good as the spray option. Always use safety glass or toughened glass, never picture glass.

1 If there is any dirt or debris inside the cupboard, wash the interior thoroughly with warm soapy water and a cloth. Allow to dry completely.

2 Carry out repair work where necessary. This cupboard door separated into four pieces of timber with little force. I re-glued the joints and held the corners together in perfect 90-degree angles using corner clamps until the glue dried. Each corner was then screwed together for extra strength.

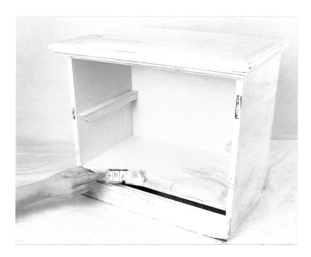

3 Remove the cupboard door prior to painting, if it is not already separate. Apply a coat of white acrylic primer to all surfaces of the cupboard and allow to dry. Then paint the interior with cream emulsion paint.

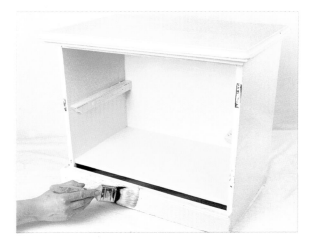

4 Paint the exterior of the cupboard and the cupboard door with soft pistachio green emulsion paint. Apply two coats for an even finish, allowing the first coat to dry before applying the second.

5 Measure the inside of the cupboard door carefully and have a glazier cut a piece of glass for you. Enlarge the template at the back of the book to the size of the glass on a photocopier. Clean the glass, then fix the photocopy on to the glass with spray mount.

6 Cut away the dark parts of the photocopy using a sharp craft knife. Pull away the cut sections to reveal the pattern left behind. The spray mount is only a temporary fixing and you should find that the paper comes away quite easily.

7 Using a slightly damp cloth, wipe away any residue of spray mount that might be left on the clear glass. Place the glass on a large sheet of paper to protect your work surface. Then spray the glass etch spray over the glass according to the instructions on the can to create the frosted effect.

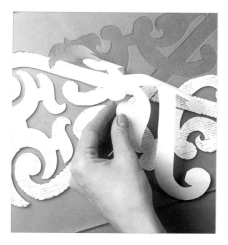

8 Allow the glass etch to dry, then carefully remove the paper pieces to reveal the clear glass pattern underneath. Lift the paper up using the point of a craft blade to avoid damaging the frosted effect. Gently wipe any spray mount from the glass as before.

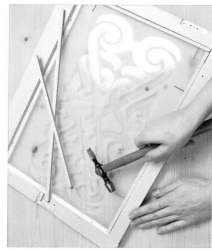

9 Measure and cut new, wooden glazing bars that will hold the glass in place on the door frame. Paint the bars with pistachio emulsion paint and allow to dry. Place the glass in the frame so the etched side is uppermost. Then secure the glazing bars in the frame by gently tapping panel pins through them; take care not to damage the delicate surface of the glass etch. Apply a coat of varnish over the painted surface of the cupboard. When dry, replace the hinges and, if necessary, add a new handle on the door.

Pebble table

This table base was bought very cheaply because there was no top to go with it. Sometimes you can find similar wooden table bases which would work equally well with this treatment. I planned to decorate this table with a pebble mosaic. I love the texture and colours of these pretty pebbles which, with their unique speckled appearance, look like tiny quails' eggs. Several garden centres now sell bags of pebbles in varying sizes and colours, but it is probably worth going to larger out-of-town centres as these tend to have more choice. I used a reddish-coloured pebble for the border of this table but your pebble effect will be determined by the type and colour of pebbles available.

As this table was to be used in a bathroom for holding towels and soaps, it did not matter that the surface was not absolutely flat; indeed, the bumpy surface gives the table its charm. If, however, you would prefer a smoother top so you could stand glasses and vases on it, you could simply fix a glass top over the pebble mosaic.

MATERIALS

table base
string
MDF, 9mm (⅜in) thick
white acrylic primer
white tile adhesive
pebbles
short wood screws

EQUIPMENT

tape measure
scissors
bradawl
pencil
jigsaw
medium-grade sandpaper
household paintbrushes
notched spreader or stiff card
screwdriver

TREATMENT A disc of MDF soon solved the problem of the table having no top, and this gave me a perfect surface on which to apply the pebble mosaic. As the pebbles are simply bedded down in wet tiling adhesive, I cannot foresee any problems using other surfaces, even melamine, provided that the surface is 'keyed' to accept tiling adhesive. If you plan to use the table elsewhere in the house, I would recommend placing a safety glass top over the pebbles. This would mean building up sides around the edge of the table to contain the glass. (For a circular table use flexiply for building up the sides.)

1 Measure the proposed width of the table top, then divide this measurement in half to determine the radius. Cut a length of string and knot a loop in each end; the string should equal the measurement of the radius. Place a bradawl in one loop and push this into the middle of the MDF. Insert a pencil into the other loop, then, keeping the string taut, draw a circle around the central bradawl within the MDF.

2 Cut out the MDF circle using a jigsaw, then rub the cut edge with sandpaper until smooth. Apply a coat of white acrylic primer to both sides of the MDF. When dry, use the same piece of string, but shortened slightly, to draw a second circle within the edge of the top, to create a border.

3 Using a notched spreader, apply white tile adhesive thickly to the top of the table. Usually the tiling adhesive is supplied with a spreader but if not, you can make your own from stiff card.

4 Working on a section at a time, push the pebbles into the wet adhesive following a circular pattern and working from the centre of the table outwards. Leave as small a gap as possible between each pebble. Continue applying pebbles in this way until you reach the border.

5 To create a strong border, place a double row of contrasting-coloured pebbles all around the edge. Do not allow the pebbles to project beyond the edge of the table top. Leave the mosaic to dry overnight. Then attach it to the table base with short wood screws, screwing them in from underneath the table.

Candle sconce

This metal pot holder and terracotta pot, intended for use in the garden, were discovered in my local charity shop and I snapped them up for very little expense. With a little bit of lateral thinking, the pot was converted from a fairly dull garden object into a rather glamorous, mirrored bathroom sconce, perfect for long candle-lit soaks in the bath.

This project shows how, with a little imagination, even the most basic objects can be completely transformed. You could follow up this theme and mosaic several more flower pots for bathroom storage; they would be ideal for all those bits and pieces that collect on bathroom shelves, such as cotton wool, make-up and even toothbrushes.

MATERIALS

terracotta pot and holder
ceramic mosaic tiles (mixed
 colours)
mirror tiles
PVA adhesive
white tile grout

EQUIPMENT

protective goggles
tile nippers
protective gloves
rotary glass cutter
cloths
glue brush
notched spreader

TREATMENT Terracotta is a perfect surface on to which to apply mosaic: tiles stick to it easily because it is porous. As flower pots come in all sorts of beautiful shapes and sizes this is a fairly inexpensive project that can guarantee a beautiful end product. Although I used the most basic of all flower pot shapes for this sconce, the results show how good even this shape can look. You could consider using the tall, elegant long tom pots or the shaped pots available at good garden centres for even more impressive results.

Swimming pool suppliers and good craft centres should be able to supply you with mosaic tiles. Mirror tiles are available from DIY stores.

1 Wearing protective goggles, snip the ceramic mosaic tiles into quarters using tile nippers. Wear protective gloves to cut the mirrored glass squares; use a rotary glass cutter to cut the tiles in half, then in half again. Repeat the halving process until you create the appropriate size of tile.

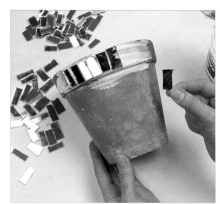

2 Clean the terracotta pot if necessary and allow to dry. Then, working on a section of the pot at a time, brush on a generous layer of PVA adhesive. Begin to apply the mirror tiles, pressing them in the glue around the collar of the pot.

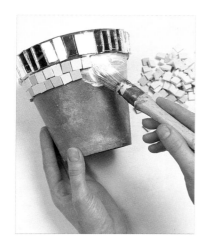

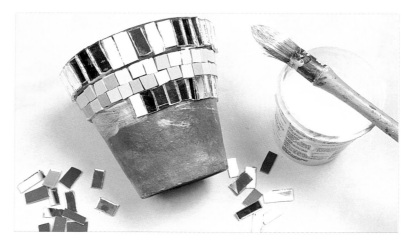

3 Once the collar has been filled with tiles, glue and fill in the section immediately below it with two rows of matt ceramic tiles. I found that working near a warm radiator speeded up the drying process, enabling me to move on to another section of the pot much more quickly.

4 Continue to work your way down the pot, sticking a second band of mirrored mosaic tiles around the centre of the pot. I particularly liked the contrast of the rectangular pieces of reflective mirror with the square pieces of matt ceramic mosaic. When you have completed the outside, apply a row of tiles to the inside edge of the pot.

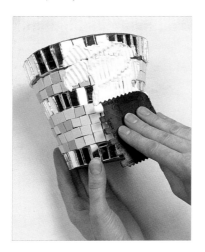

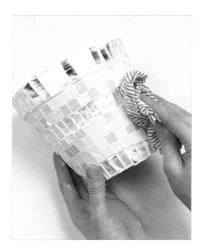

5 Rest the pot near a warm radiator to dry the PVA. Then, using a notched spreader, apply white tile grout over the surface of the mosaic, pushing the grout into the spaces between the tiles. Repeat on the inside of the pot.

6 Wipe the excess grout from the surface of the pot using a cloth. Rinse the cloth frequently and continue wiping until the surface is clear. When the pot is dry, polish the tiles with a clean cloth to remove any remaining traces of grout.

Basic
TECHNIQUES
& REPAIRS

Materials and tools

If you walk into any home improvement store or decorating shop, you will see a bewildering range of materials and equipment available. Don't worry – you do not need everything! In reality, you just need a basic tool kit which will provide you with all the bits and pieces needed to tackle most jobs, together with the standard colours of emulsion paints and some oil-based paints.

BASIC TOOL KIT

Power tools are great but there is always the equivalent in a hand-powered version. I have to say, however, that I would find life very difficult without a power sander, a power drill and a power jigsaw, but your needs really will depend on the amount of DIY you intend to undertake. If you get hooked, then you will find these tools a worthwhile investment, otherwise it might be better to borrow from a friend, hire as necessary or just make do with hand tools.

SCREWDRIVERS, both cross-head and flat-head, will be needed for practically every job. As you build up a tool kit you will find that it helps to have both a large and small version of each screwdriver, and possibly a medium size too.

A good STRIPPING KNIFE is essential, particularly if your penchant is for picking up really heavily painted pieces of junk. Too much paint can put dealers off buying a piece, as the labour required to strip it cancels out any possible profit.

A WIRE BRUSH is another useful tool if you plan on stripping your junk finds. It can access tiny cracks and crevices that your scraper blade cannot. An old toothbrush will suffice in some instances. For the lamp base project on page 60, I used a wire brush attachment for a power drill,

which is great for significantly cutting down on the time-consuming preparation stage. A long-handled wire brush will do the work as effectively although not quite as quickly.

WIRE WOOL AND SAND-PAPER are not expensive and these items will always come in useful. It is best to have a variety of grades for both: coarse, medium and fine.

ORBITAL AND PAD SANDERS are great when you need to sand large, flat areas but a delta sander will be able to access smaller, more intricate areas, corners and angles.

A FILLING KNIFE is essential for smooth filling and repairs; look for a flexible blade and a comfortable handle.

GLUES are handy to have in a basic tool kit. PVA and wood glue are my stand-bys, while a two-part epoxy glue can be useful for really strong repairs.

DETERGENT, the good old-fashioned washing-up variety, is always useful for cleaning greasy painted surfaces prior to their restoration.

SUGAR SOAP, a powerful cleaner with a caustic action is useful for washing down painted surfaces prior to painting, if the existing paint is not going to be removed. It removes grease and grime quickly and harshly. This is available in a solution either ready mixed or to be diluted, and is simply wiped over the painted surface with a cloth.

Protect your hands with rubber gloves when using sugar soap, as its powerful action will be as successful on your hands as it is on furniture.

A STAPLE GUN is a very useful tool for upholstery projects. It enables you to attach fabric directly and securely to a timber surface.

BRUSHES

There is a huge range of brushes available and generally you get what you pay for. I choose to work with brushes that will not deposit loose hairs all over my newly painted surface so I avoid buying the cheapest ones. A good basic tool kit should have a selection of the brushes described below.

Standard decorator's brushes in most sizes will equip you for the majority of the projects in this book. Sizes that range from 12mm (½in) up to 7.5cm (3in) will be sufficient for most furniture decorating and painting.

Artist's brushes are invaluable for finer detailed work. Both round and flat-headed artist's brushes, in addition to a long-haired fine brush required for lining, are useful, as are short, flat-headed stencilling brushes. I love to use the angled fitch brushes too, as these will access tight corners better than any other. Fitches are made from rather hard, stiff bristles and come in most shapes – oval, flat and angled. They are available from decorating shops and these are the decorator's equivalent of artist's brushes.

PAINT

There is a huge range of paints manufactured for the DIY market. I usually use water-based acrylic products wherever I can. With the advanced technology that is employed by today's paint manufacturers, these new water-based products can stand up to some pretty tough treatment whereas only a few years ago we would have had to use a traditional oil-based product.

WATER-BASED PAINTS are hard wearing, easy to use, they dry quickly and the brushes are easily washed out in water. Emulsion paint is the most commonly used paint on the DIY market. Some one-coat emulsion paints are now available, although these are used primarily for coating walls rather than furniture and they come in a limited palette of colours. Cheaper emulsion

paints have a poor covering power, so be warned when you are faced with the special offer of the week, as you will probably need twice as much.

Emulsion paints come in a number of different finishes: matt, sometimes called flat finish; mid sheen, sometimes referred to as vinyl silk or satin finish; and gloss, a recent addition to the water-based range, which looks like its oil-based equivalent yet is a lot easier to use.

OIL-BASED PAINT is slower drying than water-based paint but is very tough and completely washable. You will need white spirit to clean brushes and to dilute the paint if necessary. Oil-based paints are also available in three finishes: matt, or flat finish; mid sheen, known as eggshell, semi gloss or satinwood; and gloss finish.

PRIMER

An acrylic primer is often used under a paint colour as a 'key' for the top coat of paint to sit on happily. Without a priming layer, paint would in most circumstances become unstable and prone to chip. The exception to this is when a piece of furniture is prepared using E.S.P. (see page 127); in this case a primer is not necessary.

Always use the specific primer for the surface you are working on. For wooden and MDF furniture I would always use an acrylic-based primer. For metal surfaces, use a metal primer such as a red oxide primer, for the best results.

VARNISHES

There are two main varnishes – polyurethane which is oil based and acrylic which is water based. These come in three different finishes – matt, satin and gloss. Generally speaking, the higher the gloss, the tougher the finish, although all varnishes offer a good tough protection against hard knocks and scrapes. Water-based acrylic varnish is the easiest to use as it dries quickly and brushes are washed easily in water.

Avoid spray varnishes if at all possible; our planet is a better place without aerosols, and the inhalation of varnish particles can be unavoidable, particularly when using this product in a small, confined space. If using, always allow one coat of varnish to dry completely before applying subsequent layers.

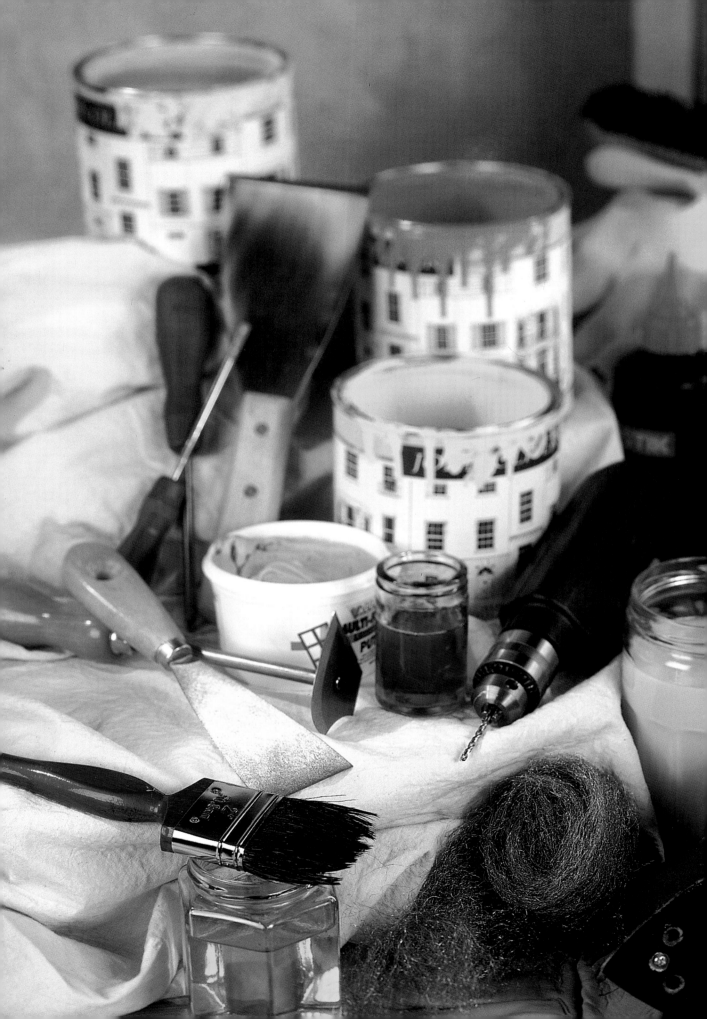

WAX

Furniture wax, the good old-fashioned kind sold in large flat tins and smelling of rich beeswax, is valuable not only for its protective qualities but also for its decorative capabilities. The application of wax over emulsion paint gives a wonderful patina of age. It darkens the underlying colour slightly and smooths the surface, giving it a silky finish. The wax may be applied softly with a cloth, or with wire wool to create a distressed finish.

Wax can be bought in many colours, usually to tone with specific wood colours, but is more often available only in a reddish tone of brown, as well as yellow-, medium- and dark-brown tones, and clear. Always apply wax at the end of a decorative treatment as all other products will be repelled by it.

OTHER MATERIALS

There are certain specific products you will need for particular projects in this book, such as acetate sheets for stencilling, and Dutch metal leaf used for gilding (see the individual projects). You may not have used these materials before, and it is worth keeping a list of good craft and decorating suppliers whom you can call upon for advice.

Caution
Take particular care when using strong chemicals, abrasive materials and sharp tools on any furniture makeover at home. Wear gloves at all times to protect your hands from chemicals and a face mask too if possible. A mask is crucial when sawing medium-density fibreboard (MDF) and if possible cut it outside or at the very least in a well-ventilated room, as the tiny dust particles are suspected of being carcinogenic. Be warned.

Essential techniques

The advice provided in the next few pages outlines the unfortunately rather time-consuming, yet fundamental, preparation techniques for getting your piece of furniture ready for its all-important transformation; it is the boring bit, if you like, as opposed to the fun part of decoration. As is the case with many decorating projects, it is this preparation which accounts for all the hard work, and decorating junk furniture is no exception. If you're not opposed to hard work, even the most severely junked piece of furniture – the sort found at the back of a charity shop or under a table at the local car boot sale – can be given new life.

Rescuing a piece of furniture that is in dire need of repair can be immensely rewarding, but be honest with yourself: if the thought of hours spent alone with only your paint stripper and scraper knife for company isn't exactly how you'd like to spend your well-earned weekend off, then perhaps you had better look for something that is in a slightly better condition.

SPECIAL PAINT FINISHES

Once you have completed the preparation, then you can have fun trying some of the many special paint finishes used throughout this book. Antiquing, distressing, colourwashing and gilding can all be used to give your furniture a distinctive touch and most of them are easy to do. Rather than applying just one coat of emulsion, for example, why not apply two and distress one through the other? The effect is more pleasing to the eye and it adds a strong character to a piece of furniture.

There is a current taste for heavily antiqued furniture, using glazes, waxes or varnish. The simplest way to build a patina of age on a piece of furniture is to apply a coloured finishing wax; another method involves distressing the painted surface with a pad of wire wool. These finishes can be used either on their own or combined with other techniques to enhance your furniture.

Preparation

Preparation is without doubt the most boring and labour-intensive part of any DIY job, and it is usually dirty, dusty and grimy to boot. Yet thorough preparation is essential if you want to avoid the situation where the piece of junk so lovingly and painstakingly restored, suddenly succumbs to peeling paint syndrome, cracks begin to appear in the varnish, and the finish flakes off on to the carpet. There are few things more demoralising than watching all your hard work go to waste in this way. Careful preparation always pays off in the long run. Fortunately there are a number of short-cuts that can make the work easier and more tolerable. This brief section introduces some up-to-the-minute products and fail-safe techniques for thorough preparation.

STRIPPING

Sometimes with heavily varnished or painted surfaces there is no other option than to strip the accumulated layers back to the original base. The quickest and easiest way to do this is to use a commercial paint stripper in liquid or gel form. Let your local hardware store advise you on the right product for your particular piece of furniture since there are many brands on the market. Use low-solvent, environmentally friendly products wherever possible. Chemical wood and varnish strippers have benefited from technological advances and are no longer as bad for our planet as they once were. Seek these products out and if your local store does not stock them, ask for them. The more consumers demand these products, the sooner everyone will be using them. Always follow the instructions on the can, and dispose of waste material with caution and care.

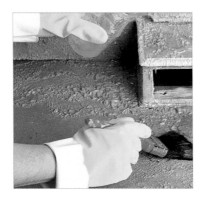 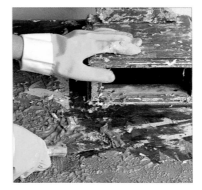

1 Decant a little stripper into a clean, dry glass jar; this is easier than tipping it directly on to the furniture from the can. Apply the stripper to your furniture with a brush, using a dabbing action. If the piece is quite large, work on a small section at a time. Leave the stripper to soak into the painted surface for the time recommended by the manufacturer.

2 The stripper will cause the paint surface to blister quite dramatically. When the recommended time is up, remove the old paint layers with a stripping knife, pushing the knife away from you. Scrape the old paint into a bag or container that can be disposed of once the job is finished.

3 Once the thickest part of the paint has been removed, clean off any remaining bits using a pad of medium-grade wire wool soaked in white spirit. Rub this into the surface of the piece reasonably hard until the surface is clean. If the pad becomes clogged with paint, turn it over or replace it with a fresh pad.

Caution
Wear strong household gloves and eye protection when using paint stripper. Masks do not protect you from the fumes of methylene chloride, the toxic active ingredient in stripper.

E.S.P.

A fairytale product in a can for those in love with painted furniture, Easy Surface Preparation comes in liquid form and is available by mail order (see suppliers list). It is a tried-and-tested American product that is now starting to appear in Europe and the UK. Use E.S.P. in a well-ventilated space; apply it directly to the furniture, wait for five minutes, then wipe off with a cloth. Ninety minutes later, the surface is ready for you to apply the base colour. No sanding, priming, or undercoating is necessary: the paint will bond to the treated surface, be it wood, melamine, veneer or ceramic. Just follow the instructions carefully and you can't go wrong – it's a dream.

Apply E.S.P. directly on to the surface and simply wipe off with a cloth after five minutes. Leave for ninety minutes before painting on your chosen colour.

PREPARING METAL SURFACES

Occasionally I have uncovered wonderful pieces of junk that are made of metal. Often these pieces are only junked because they are rusty, but most metalwork is pretty easy to clean up. Often the most that is needed to prepare metalwork is a thorough brush-down with a stiff wire brush. The rust will then flake off to reveal shiny metal beneath. Choose a strong wire brush and rub the metal surface with this until the rust has literally been scrubbed off. Metal primer is used whenever you are applying paint to a metal surface. One coat is usually sufficient.

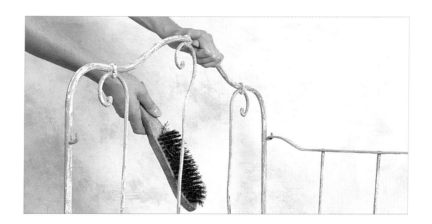

1 Scrub the rusty metal surface using a stiff wire brush, brushing away from you to avoid spraying yourself with fragments of rusty metal. Work systematically around the item until the whole surface has been treated. Scrub the underneath surface in the same way as the top.

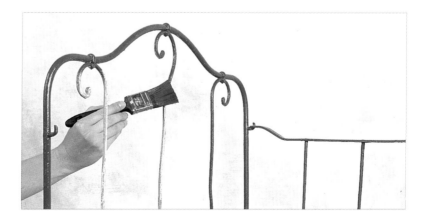

2 Using a paintbrush, apply metal primer over the surface including underneath. I use a red metal oxide primer and one coat is usually sufficient. Drying times vary, but as the primer is solvent based it will take several hours to dry even in a well ventilated space. Work outdoors if possible.

Basic repairs

FILLING

The aim of good preparation is to have the smoothest possible finish on the furniture you are about to paint or decorate. Junk furniture, by its very nature, is likely to need some kind of repair such as filling a small hole or crack before you can give the piece a new, exciting look.

A ready-mixed, all-purpose wood putty solves most problems; it is easy to apply, dries quickly, and can be sanded smooth so that no one would ever suspect the damage underneath. Filler also comes as a powder which is mixed with water to form a paste. Ensure the filler is completely dry before painting.

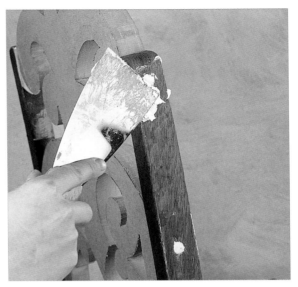

■ For small holes, first sand around the outside of the hole using fine sandpaper, then apply a little filler with a filling knife. Spread the flat filler blade over the hole, pressing deeply into the recess. Scrape away any excess filler and allow to dry. The drying time will depend on atmospheric conditions and on the depth of the hole. The filler may shrink slightly when it has dried so fill again for the second time.

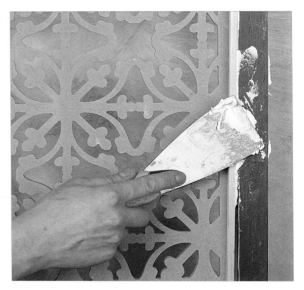

■ For cracks, follow the same procedure as for filling holes, using the blade to push the filler into the crack. For hairline cracks it is often advisable to open up the crack with a craft blade so it can accept a larger amount of filler.

REPAIRING HINGES

There is nothing worse than a wobbly or ill-fitting door. Fortunately, the only action often needed to repair an ill-fitting door is to tighten up the hinges, which may have become loose with general wear and tear. The screws can either be adjusted or if necessary replaced and the existing hinges will keep the door perfectly balanced for a long while. If the screws are damaged or missing, I like to replace them with new brass ones; these should be slightly larger than the old ones so that a stronger fixing is made. When choosing a new screw, always check that the furniture can accommodate the screw's length and width.

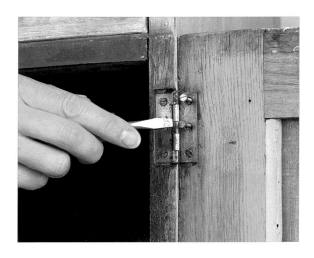

Hold the door firmly in its correct alignment and tighten up the screws.

FIXING LOOSE JOINTS

Many loose joints on junk furniture are primarily a result of heavy usage. Regluing will often rectify this type of problem quickly, and using modern glues such as PVA and strong wood glue will ensure that the joints stay closed for longer.

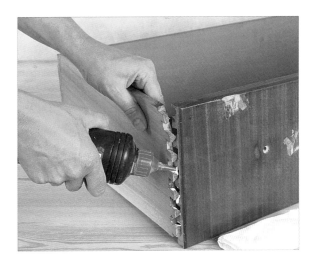

1 Open the joints as wide as possible without causing any more harm than is necessary to the piece of furniture. Apply glue to the joints, using the nozzle of the wood glue tube to direct the glue into the joints themselves. When regluing, always use too much rather than too little glue; any excess adhesive can be wiped away with a clean cloth.

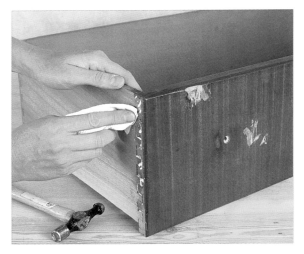

2 Press the two sides together and hold firmly for a few minutes. Wipe excess glue from around the joint with a clean cloth. It may be necessary to tap the joints together lightly using a small hammer. Wherever possible, clamp the joint to secure the repair until the glue dries; in most cases, you should allow glue to dry overnight.

SANDING

The power sander makes light work of this preparation stage and is a wise investment if you get hooked on furniture revamps. You will still have to use hand-sanding methods for some tasks though.

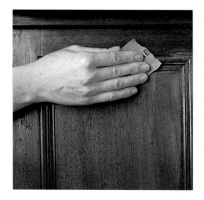

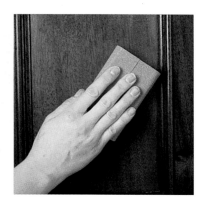

■ Fine details such as mouldings or architrave should be sanded with pieces of sandpaper by hand. Fingertips are sensitive to the curves of the woodwork and can manipulate the sandpaper around the detailed mouldings in a sympathetic way.

■ Use a cork sanding block or a pre-fabricated, flexible sanding block for flat areas that are too small for a power sander. The block sander is more responsive to touch, so when a fine finish is required it can be easier to 'sense' the level of finish and gently even out lumps or bumps that would be hard to detect with a power sander.

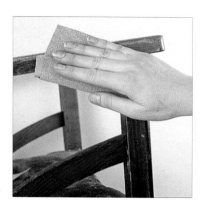

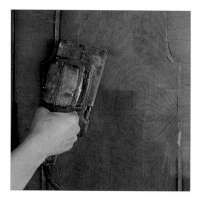

■ When working around shapes such as the arm of a chair, use a piece of sandpaper with the ends folded around the palm of your hand. Renew the paper when necessary to prevent clogging.

■ Power sanders give their best results when used on large flat surfaces such as door panels.

SEALING AND VARNISHING

The final finishing touch for any furniture project is to add a coat or two of varnish or a layer of wax. Not only does this give an attractive finish but it also acts as a protective layer.

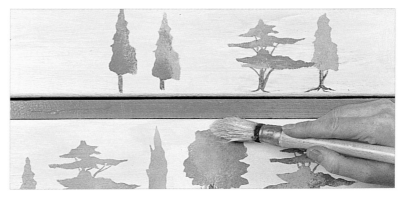

▓ ·Choose a varnish finish to suit the your recently decorated furniture – either matt, satin or gloss. Apply the varnish in an even layer with a good paintbrush with secure bristles. A second coat will add to the durability of the piece.

▓ Wax may be applied either with a cloth or with a pad of wire wool. If you are seeking an antiqued effect, use wire wool to apply the wax as this will distress the underlying paint slightly, adding to the overall effect.

Finishing touches

CHANGING A DRAWER KNOB

It may sound basic, but it is surprising how much difference a small drawer knob can make to a piece of furniture. The new handles I found for the revamped writing desk for example, were the perfecting finishing touch to the transformation. Recently I discovered an entire shop devoted solely to knobs! New designers are also beginning to advertise beautiful cabinet pulls, door furniture and drawer knobs in the classified adverts at the back of many design and home interest magazines, so check these pages too if you're looking for new ideas.

Remove the old drawer pull from the junk furniture using a screwdriver. If you clean away the dirt and grime that tends to collect around the screw heads on old furniture, you will usually be able to reveal the screw head sufficiently to unscrew the fixings. Rusted-in screws that steadfastly refuse to budge will either need to be cut off with a fretsaw, or sometimes drilled out.

1 Fill the holes that are left after the removal of the old drawer pull using a small amount of wood filler. Push the filler into the holes as you pull the spreader past them, and scrape away any excess from around the sides of the repair. Allow the filler to dry, then sand lightly to a smooth finish.

2 For a central fixing knob, measure across the width and depth of the drawer to determine the central position. Lightly mark the spot with a pencil cross.

3 For a central screw-fitting drawer knob, use the pencil mark as a guide for the drill. Fix a wood drilling bit into the drill, choosing a bit that is slightly smaller in diameter than the screw itself. Hold the drawer firmly with one hand and drill vertically into the drawer.

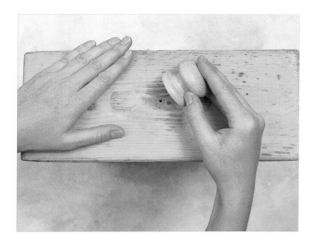

4 Screw the knob into the hole. Sometimes wooden knobs such as this one are purchased with the screw fixed in place. Other knobs require a screw to be passed through from inside the drawer, through the drilled hole and into the wooden knob.

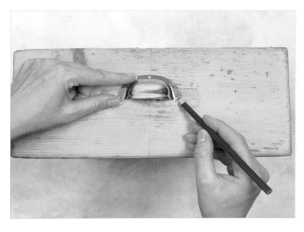

5 For a drawer pull like this one that requires three screws, position the handle over the centre of the drawer, marking in the centre line if necessary to align the handle correctly. Using a light pencil, mark through the screw-hole positions, remove the handle and use the pencilled marks as guides for the drill.

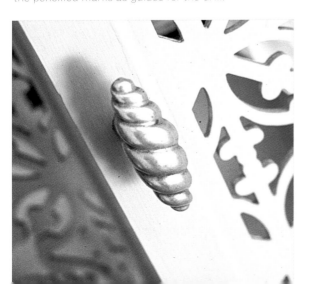

DECORATING A DRAWER KNOB

Wooden knobs are easy to decorate; treat them as you would any blank surface. Choose unfinished wood if at all possible, as this needs no preparation at all. For wood that has been previously lacquered or waxed, simply prepare it as if it were a piece of furniture. Wire wool soaked in a little white spirit will remove wax, and sanding will 'key' an ultra-smooth surface such as lacquer. If the knobs are painted, then either sand them or use a little paint stripper.

Metal knobs can also be decorated successfully. To create an antique finish on a new brass knob, mix a little burnt umber oil colour with a little polyurethane varnish and stipple the colour over the brass surface.

Distressed colours such as bright yellow showing underneath a slate blue can be effective on a country-style piece of furniture. For the most effective results when distressing, choose colours that are opposite on the colour spectrum, as shown here.

Découpage can also be very effective on drawer knobs. Once again, choose a background colour that will set off the applied découpage. Tint the découpage using watercolours for a softer look; alternatively, a graphic look may be achieved by applying a black and white image on to a dark base colour. Glue the découpaged motif in position, then protect and seal it with at least three layers of acrylic varnish.

Templates

Frosted glass cabinet page 104

Stencilled chest of drawers page 74

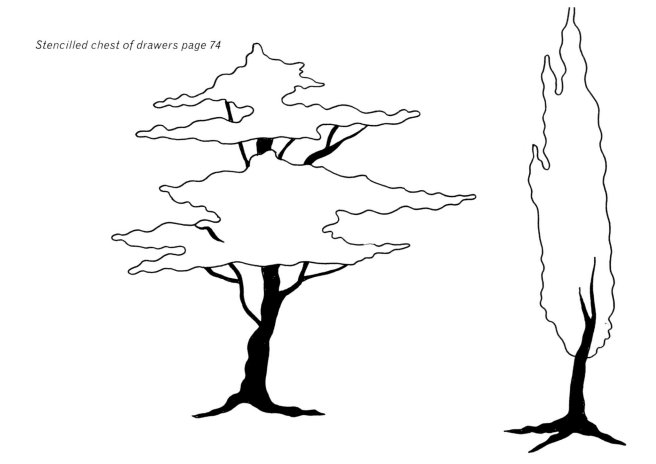

Découpaged cabinet page 52

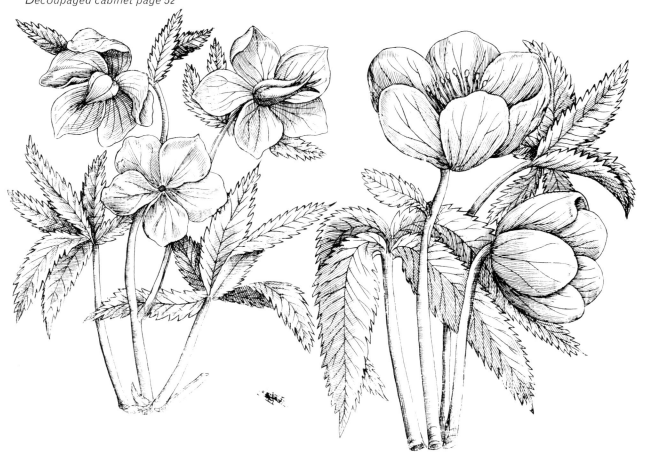

Tea trolley page 20

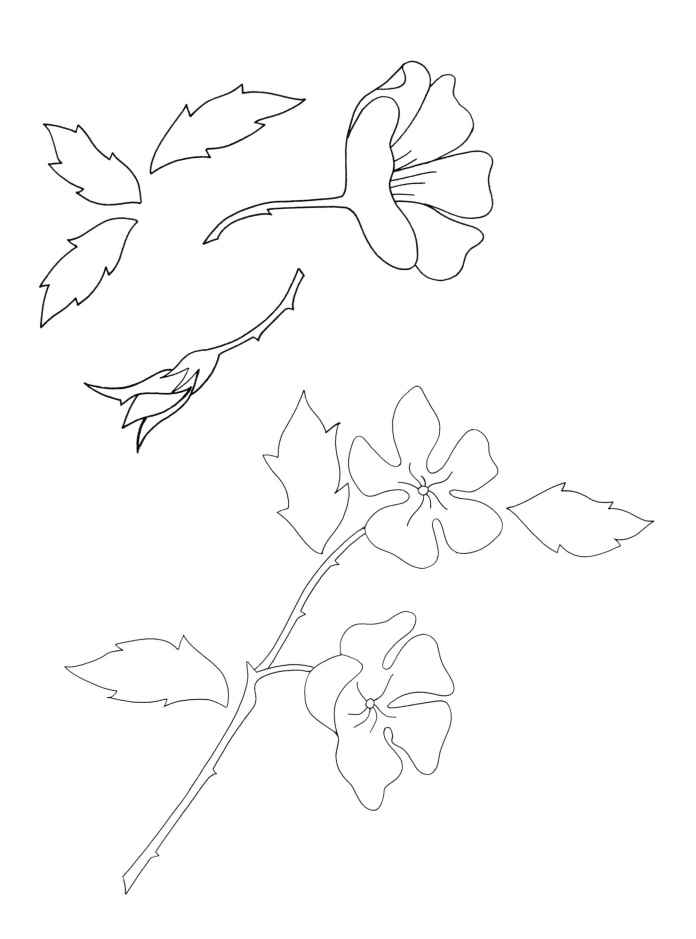

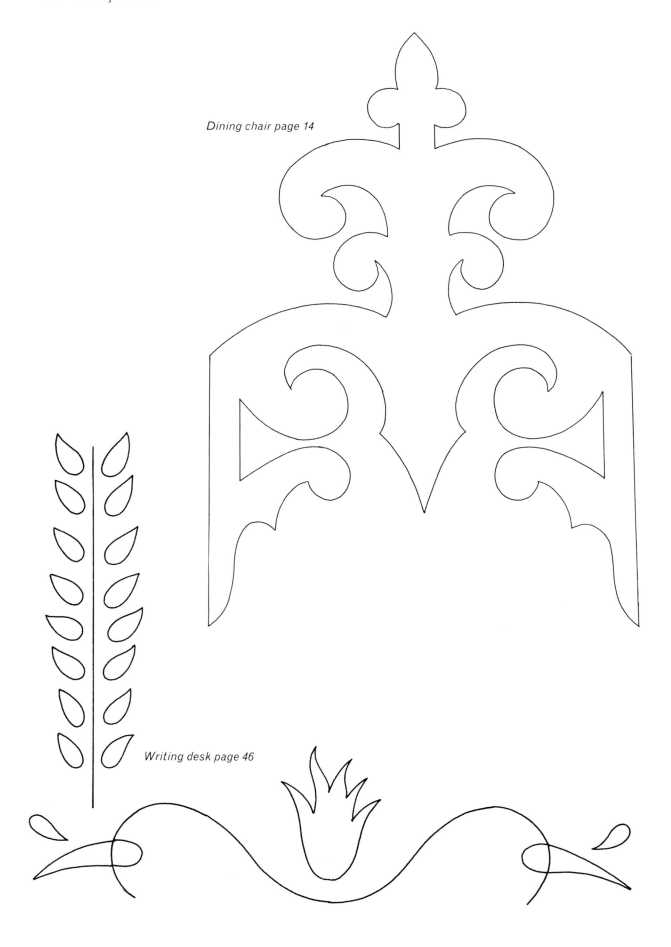

Dining chair page 14

Writing desk page 46

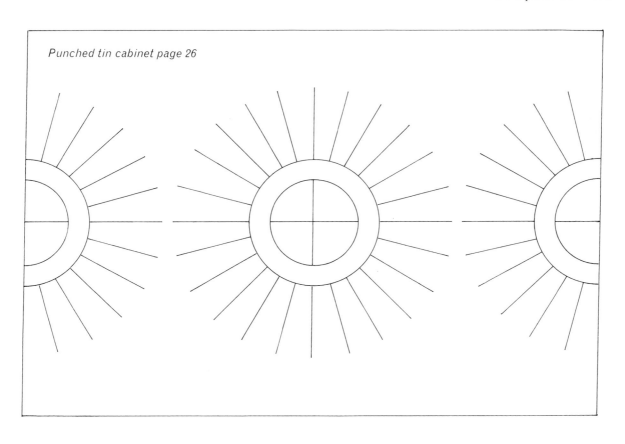

Punched tin cabinet page 26

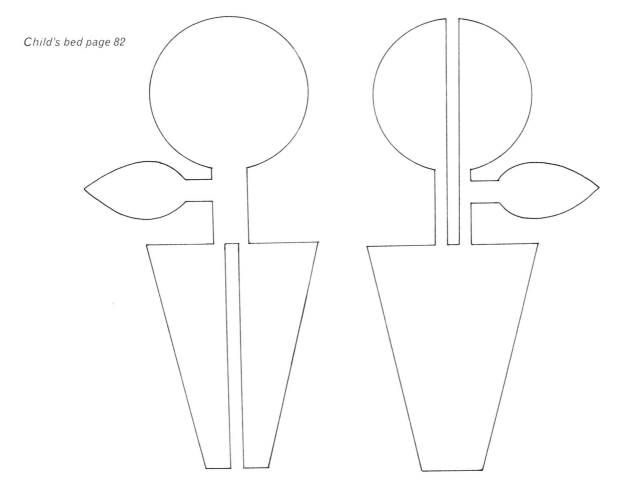

Child's bed page 82

Suppliers UK

TEXTILES

J. D. McDougall Ltd.
4 McGrath Road
London E15 4JP
Tel: 0181 534 2921
Canvas, hessian (ring for an appointment)

Russell & Chapple Ltd.
23 Monmouth Street
Covent Garden
London WC1 9DD
Tel: 0171 836 7521
Canvas, hessian and art suppliers

PAINTS

Cornelissen & Son
105 Great Russell Street
London WC1B 3LX
Tel: 0171 636 1045

Foxell & James
57 Farringdon Road
London EC1M 3JB
Tel: 0171 405 0152
Varnishes, stains, paints

Green & Stone
259 Kings Road
London SW3 5EL
Tel: 0171 352 0837
Fax: 0171 351 1098
Glazes, artists' materials

J. H. Ratcliffe & Co.
135a Linaker Street
Southport PR8 5DF
Tel: 01704 537999
Scumble glazes, varnishes (mail order)

John Oliver Paints
33 Pembridge Road
London W11 3HG
Tel: 0171 221 6466
Paint colours in own range, papers

Nutshell Natural Paint
10 High Street
Totnes
Devon TQ9 5RY
Tel: 01803 867770
Earth and mineral pigments. Natural paints, waxes

PAPERS & PAINTS

4 Park Walk
London SW10 0AD
Tel: 0171 352 8626
Paints, glazes

Ray Munn Paints
861/863 Fulham Road
London SW6 5HP
Tel: 0171 736 9876
Ray Munn is the main supplier of all paints, varnishes, stains, waxes, glazes and E.S.P. for this book

FABRIC COLOURS

London Graphic Centre
107/115 Long Acre
London WC2E 9NT
Tel: 0171 240 0095
Fabric paints, art suppliers

GILDING

Alec Tiranti Ltd.
27 Warren Street
London W1P 5DG
Tel: 0171 636 8565

Alec Tiranti Ltd.
70 High Street
Theale
Reading
Berkshire RG7 5AR
Tel: 0118 9302775

Cornelissen & Son
(see address above)

Green & Stone
(see address above)

MOSAICS

Edgar Udny & Co Ltd.
314 Balham High Street
Balham
London SW17 7AA
Tel: 0181 767 8181
Fax: 0181 767 7709

Reed Harris Tiles
Riverside House
27 Carnwath Road
Fulham
London SW6 3HR
Tel: 0171 736 7511
Fax: 0171 736 2988

FINISHING TOUCHES

JALI Ltd.
Apsley House
Chartham
Canterbury
Kent CT4 7HT
Tel: 01227 831710
Fretwork panels

Turnstyle Designs
Village Street
Bishops Tawton
Barnstaple
Devon EX23 0DG
Tel: 01271 325325
Fax: 01271 328 248
Replacement handles

SALVAGE

London
Brondesbury Architectural
Reclamation
Willesden Lane
London NW6 7TE
Tel: 0171 328 0820
Fax: 0171 328 0280

LASSCo
St Michael's Church
Mark Street, off Paul Street
London EC2A 4ER
Tel: 0171 739 0448
Fax: 0171 729 6853
Email: lassco@vetnet.co.uk

The Old Bath House
65 Bell Green
Sydenham SE26 5SJ
Tel: 0181 778 6909

Totem Interiors
Hornsey
London N8
Tel: 0181 981 7705

South East England
Brighton Architectural Salvage
33 Gloucester Road
Brighton BN1 4AQ
Tel: 01273 681656

Drummonds of Bramley
Birtley Farm
Bramley, Guildford
Surrey GU5 0LA
Tel: 01483 898766
Fax: 01483 894393

South West England
Dorset Reclamation
Cowdrove
Beer Regus
Wareham
Dorset BH20 7JZ
Tel: 01929 472200

Elmtree Reclamation
Site 45 Victory Road
Wilts Trading Estate
Westbury
Wiltshire BA13 4JL
Tel: 01373 826486

Walcott Reclamation
108 Walcott Street
Bath BA1 5BG
Tel: 01225 444404

Midlands
Rococo Architectural Antiques
Lower Weedon Beck
Northamptonshire
Tel: 01327 341288

The Architectural Salvage Store
Unit 6 Darvells Works
Common Road
Chorleywood
Hertfordshire WD3 5LP
Tel: 01923 284196
Fax: 01923 282214

Northern England
Borders Architectural Antiques
2 South Road
Wooler
Northumberland NE71 6SN
Tel: 01668 282475

Kevin Marshall's Antique
Warehouse
17/20a Wilton Street
Hull HU8 7LQ
Tel: 01482 326559

Shiners Architectural
Reclamation
123 Jesmond Road
Jesmond
Newcastle Upon Tyne NE2 1JY
Tel: 0191 2816474
Fax: 0191 2819041

Wales
D. & P. Theodore, Sons and
Daughters
Building Salvage and
Reclamation
Bridgend Industrial Estate
Princess Way
Mid-Glamorgan
Tel: 01656 648936

Scotland
Auldearn Architechural Antiques
Dalmore Manse
Lethen Road
Auldearn
Nairn
Inverness
Tel: 01667 453087

Edinburgh and Glasgow
Architectural Salvage Yards
Unit 6 Couper Street
Leith
Edinburgh EH6 6HH
Tel: 0131 5547077
Fax: 0131 5543070

Northern Ireland
Architectural Salvage
Jennymount Street
Belfast
15 3HW
Tel: 01232 351475

Suppliers US

Dick Blick Fine Arts Co.
P.O. Box 1267
Galesburg, Il 61402-1267
Tel: 1-800-447-8192
*Catalog, artist's paints, speciality
and artist's brushes, crackle
medium, .005 tooling aluminium,
gilding supplies*

Pearl Paint
308 Canal Street
New York, NY 10013
Tel: 212-431-7932 (800-221-6845
outside New York)
*Catalog, artist's paints, interior
paints, glaze mediums and finish-
es, speciality and artist's brushes,
crackle medium, gilding supplies,
paint strippers, abrasive papers,
pre-cut stencils, mylar, tapes*

Janovic Plaza
30-35 Thomson Avenue
Long Island City, NY 11101
Tel: 800-772-4381
*No catalog, interior paints, glaze
mediums and finishes/varnishes,
speciality brushes, crackle me
dium, gilding supplies, paint
strippers, abrasive papers, pre-cut
stencils, tapes*

Albert Constatine & Sons
2050 Eastchester Road
Bronx, NY 10461
Tel: 800-223-8087
*Catalog, finishes/varnishes,
gilding supplies, paint strippers,
abrasive papers, wood glues,
clamps, decorative hardware,
clear and tinted antiquing
furniture waxes, wood bleaches*

Woodworker's Supply, Inc.
5604 Alameda Pl. NE
Albuquerque, NM 87113
Tel: 800-645-9292
*Catalog, finishes/varnishes,
gilding supplies, paint strippers,
abrasive papers, wood glues,
clamps, decorative hardware,
clear furniture waxes and tinted
liming and patinating waxes,
wood bleaches*

Standard Tile
255 Route 46 West
Totowa, NJ
Tel: 1-800-648-8453
*Ceramic mosaic tile, no catalog,
will ship anywhere*

Sam Flax, Inc.
425 Park Avenue
New York
NY 10022
Tel: 212-620-3060

Daniel Smith
4150 First Avenue
Seattle
WA 98134
Tel: 206-223-9599

Garrett Wade
161 Avenue of Americas
New York
NY 10013
Tel: 212-807-1155

Maiwa Handprints
6-1666 Johnston Street
Granville Island, Vancouver
British Columbia V6H 3S2
Canada
Tel: 604-669-3939

Dover Publications
31 East 2nd Street
Mineola
NY 11501
Tel: 516-294-7000
Tel in Canada: 416-445-3333
Papers

Kate's Paperie
561 Broadway
New York
NY 11012
Tel: 800-809-9880
Papers

Laila's
1136 Lorimar Drive
Mississauga
Ontario L5S 1R7
Canada
Tel: 905-795-8955
Papers

Index

Acknowledgements

The publishers would like to thank the following companies for their help in supplying items which appear in the photographs:-
Designers Guild, 271 & 272 Kings Road, London W1; Habitat, The Heals Building, 196 Tottenham Court Road, London W1; Lunn Antiques, 86 New Kings Road, London SW6 4LU for linen used in bedroom shots; Eden, 127 Church Road, Barnes, London SW13 for crockery in tea trolley shot; Ikea, telephone (0181) 208 5608; Papyrus, 48 Fulham Road, London SW3 6HH for paper on writing desk.

420-011